5-30-09

# *See* ROCK CITY

### THE HISTORY OF
## *Rock City Gardens*

## TIM HOLLIS

Charleston · London

THE
History
PRESS

Published by The History Press
Charleston, SC 29403
www.historypress.net

First published 2009

Printed in China by Everbest Printing Co.
through Four Colour Print Group in Louisville, Kentucky

ISBN 978.1.59629.577.3

Library of Congress Cataloging-in-Publication Data

Hollis, Tim.
See Rock City : the history of Rock City Gardens / Tim Hollis.
p. cm.
Includes bibliographical references.
ISBN 978-1-59629-577-3
1. Rock City Gardens (Ga.)--History. 2. Formations (Geology)--Tennessee--
Chattanooga Region--History. 3. Gardens--Tennessee--Chattanooga Region-
-History. 4. Amusement parks--Tennessee--Chattanooga Region--History. 5.
Lookout Mountain (Appalachian Mountains)--History. 6. Chattanooga Region
(Tenn.)--History, Local. 7. Chattanooga Region (Tenn.)--Buildings, structures,
etc. I. Title.
F443.L8H65 2009
976.8'82--dc22
2008045284

# CONTENTS

# INTRODUCTION

*"In the beginning, God created the heavens and the earth."*

The writer of Genesis could have added "and also Rock City" because geologists agree that the basic construction of this world-famous tourist attraction began approximately 200 million years ago (give or take a few million). Its relationship with human beings is considerably more modern, stretching back only a few millennia. There is evidence that Native Americans moved into Lookout Mountain's neighborhood as long ago as the time of Christ. The Indians called the mountain "Chatanuga," meaning "rock coming to a point." These ancient residents of Chatanuga/ Lookout had quite an advanced civilization and were probably the first human beings to "SEE ROCK CITY."

In 1823, two missionaries, Daniel S. Butrick and William Chamberlain, arrived in the area to minister to the Indians. On August 28, Reverend Butrick made the following entry in his diary:

> *In company with Mr. Chamberlain, I ascended Lookout Mountain to visit a citadel of rocks. This is just at the top of the mountain, and is composed of rocks as high as houses of one, two or three stories. It is so situated as to afford streets and lanes, and to form many convenient shelters from the heat, wind and rain.*
>
> *Especially, we noticed one apartment twelve by fifteen and six feet high in the highest place, arched overhead and walled on each side by solid rock, except an opening for a door, and one or two*

*places in the corners which would serve for chimneys. This natural
fortress was formerly inhabited by the Creeks. We saw where they
hung their meat and where they prepared their lodgings. Here, after
viewing for a moment the wonders of the Omnipotent, being retired
from the world, we bowed with adoration before Him, whose favor
is compared with the shadow of a great rock in a weary land.*

Reverends Butrick and Chamberlain did not run back home to
begin painting barn roofs and birdhouses with descriptions of what
they had seen, but as more and more settlers began to move into
the area, that part of the mountain became a well-known object of
curiosity. The book *Children of Pride*, by Robert M. Myers, reported
on a visit to Lookout on October 20, 1855:

*There is a very good road all the way up. In some places pretty
steep, but for the greater part the ascent is easy. The road winds
up through the trees along the sides of deep and immense ravines,
while large masses of rock are all around you, above and below...
The mountain is so thickly wooded that a view of the surrounding
country is quite impracticable while one is ascending...*

*We occupied the rest of the afternoon visiting the Rock City.
Just imagine rocks fifty feet in height, piled against each other,
forming as it were underground passageways; I felt as though
I was wandering among the ruins of some giant's castle. Not
that the rocks at all assume any regular forms, but there are long
passages between them, sometimes covered, narrow, and then
suddenly widening into large halls.*

Rock City's history as a tourist destination might have begun
around this time had it not been for the intervention of a certain
war that tore the United States apart into North and South and then
put it back together again, leaving scars that proved difficult to heal.
Lookout Mountain, of course, was the focal point of a well-known
military campaign, but as far as can be determined there was no
actual fighting within the dominions of Rock City. However, during
the conflict, both a Union officer and a Confederate nurse made
separate diary entries reporting that one could supposedly "see

seven states" from atop the mountain. The origin of this familiar claim is unknown, but since one of the seven—Alabama—had only been a state since 1819, it would seem that, at the time of the war, the slogan could not have been more than fifty years old.

Once the shooting was over and Lookout had settled back into some semblance of serenity, people were able to get back to paying attention to the eccentric rock formations on the mountain's peak. The August 26, 1871 issue of *Appleton's Journal* featured on its cover a beautiful woodcut illustration of "Rock City, Lookout Mountain" and an inside article by O.B. Bunce to go along with it. It read in part:

> *Vast rocks of the most varied and fantastic shape are arranged into avenues almost as regular as the streets of a city. Names, indeed, have been given to some of the main thoroughfares, through which one may travel between great masses of the oddest architecture conceivable. Sometimes these structures are nearly square, and front the avenue with all the imposing dignity of a Fifth Avenue mansion. But others exhibit a perfect license in capricious variety of form. Some are scooped out at the lower portion, and overhang their base in ponderous balconies of rock. Others stand balanced on small pivots of rock, and apparently defy the law of gravitation. I know of nothing more quaint and strange than the aspects of this mock city...silent, shadowy, deserted, and suggestive, some way, of*

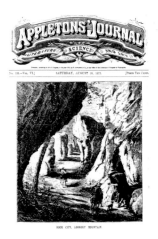

An 1871 issue of *Appleton's Journal* featured this early illustration of "Rock City, Lookout Mountain," long before anyone thought of developing the property as a tourist attraction. *Rock City collection.*

*a strange life once within its borders. One expects to hear a footfall,*
*to see the ponderous rocks open and give forth life, to awaken the*
*sleep that hushes the dumb city in a repose so profound.*

Five years later, another part of the Rock City legend made its first appearance in print, in a book with the card catalogue—busting name of *Chattanooga, Tennessee, Hamilton County & Lookout Mountain, An Epitome of Chattanooga from Her Early Days Down to the Present; Hamilton County, Its Soil, Climate Area, Population, Wealth, Etc.; Lookout Mountain, Its Battlefields, Beauties, Climate, and Other Attractions.* The author was Louis L. Parham, who deserves a round of applause just for creating that title. The book listed the five "principal views" of Rock City as it existed at the time: "Pedestal Rock," "Twin Sisters," "Elephant Rock," "Street View" and "Fat Man's Misery." But the most significant thing about this volume was its inclusion of an Indian legend with *Romeo and Juliet* overtones. It seems that a young brave named Sautee had fallen in love with Nacoochee, a princess of an enemy tribe, and in the usual overreaction so typical of such stories, Nacoochee's enraged father ordered the swain to be thrown off the precipice of Lookout. The foul deed having been perpetrated, Nacoochee sprang over the cliff after her rapidly disappearing lover, and Rock City's star attraction, Lover's Leap, passed into folklore.

Just how factual this legend really is might, of course, be open to speculation. Around the world there are numerous mountain ledges from which despondent lovers are said to have ended it all for varying reasons, and some of those other spots are called "Lover's Leap" as well. However, there is a possibility that the story of Rock City's Lover's Leap may go just a bit deeper than other similar legends. Just across the Georgia state line, on State Highway 17, there are two neighboring communities, so small that they do not even appear on most maps. One town is named Sautee, and the other, two miles away, is called—you guessed it—Nacoochee. And so, the legend lives on.

While Sautee and Nacoochee, both the lovers and the communities named for them, slept peacefully in their valley, Lookout Mountain was becoming a flurry of activity. Railroads and highways were constructed in the 1880s to make access to the mountain's crest easier, the first Lookout Mountain Incline began hauling visitors up

Lover's Leap was always one of the principal features of the tract that was to become Rock City. As you can see, when the attraction first opened, no walls or other improvements had been made at the projecting precipice. *Rock City collection.*

the side in 1887 and enterprising businessmen built luxury hotels on the peak. Lookout had one of its earliest tourist attractions in Natural Bridge Park, which featured oddball rock formations very similar to those in the still-undeveloped Rock City. The Civil War site on the mountain's northernmost extremity was dedicated as Point Park in 1898, and the nearby battlefield at Chickamauga, Georgia, became a national military park at the same time. People were beginning to look out for Lookout Mountain, and it was ready for them.

With the increase in visitors, the area known to all as Rock City became a popular spot for hiking parties and picnics. Robert Sparks Walker, a Lookout Mountain historian, decided to "SEE ROCK CITY" in 1919, and he recorded the following observation:

> *In company with a hiking companion and my ten-year-old son, we climbed Lookout Mountain on foot from its eastern base to the summit. From there we wandered along a trail among forest trees, wild flowers, and shrubs. After passing many monstrous rocks from the size of Jumbo, the big elephant, to that of a two-story residence, we entered the famous Rock City which has been known to Indians for hundreds of years.*

Clearly, Rock City was sitting there as it had for several million years, waiting for some individual with uncommon foresight to develop it to its full potential. That individual would indeed come, but he would have to undergo quite a preparatory period before he would be ready to undertake the project. His name was John Garnet Carter.

*Chapter 1*

# THE KING OF FAIRYLAND

The man who was to make Rock City a household name was, appropriately enough, himself a product of the Tennessee hills. Garnet Carter was born on February 9, 1883, in Sweetwater. Garnet's father, James Inman Carter, had a mercantile business in the town at the time of his son's birth, but just two years later the whole family (now including a daughter, Mary Lynn) packed up and moved to Chicago, where James became a member of the Chicago Board of Trade. While in Chicago, another member was added to the family with the arrival of Paul Carter in 1888.

The Carters returned to Tennessee in 1891. This time they settled in Chattanooga, where another daughter, Lucile, was born. In 1894, the family left the bustle of downtown Chattanooga for the more peaceful and beautiful slopes of Lookout Mountain, where yet another daughter, Doris, joined the clan in 1900. There would have been no way for young Garnet to predict that the bulk of his future life would be tied up with that mountain.

Most of what we know about the Carter boys' early life on Lookout comes from an extensive interview conducted with Paul Carter in 1974. Paul gave a marvelously evocative portrait of Lookout in the days when tourists were just beginning to take note of it in great numbers:

> *At this time, only one road served the mountain, it being a very poor toll road. Now, having been greatly improved, it is called the Ochs Highway* [Highway 58]. *By the latter part of the*

*1890s, Lookout Mountain began coming into its own. Lookout Inn, a 400-room hotel, was built across from the present Incline Station, and the present Incline and a broad-gauge steam engine track were built from St. Elmo to the top of the mountain... The railroad was a great factor in the growth of the mountain, hauling building materials, coal, and such.*

*Living on the mountain in those days was quite crude. There were no hard-surfaced roads, no running water in homes, and houses were poorly sealed. In the winter the rooms were quite cold, warmed either by grate fireplaces or stoves. All homes had privies located in the back yards. Conveyance was by horse and buggy or wagon. There were no telephones or fire departments.*

*One incident I remember is a time when a group of us were going out to Moore's Pond in Georgia to swim. This pond was located about a half mile north of where Bill Penley lived. Knowing that Mr. Penley had some peach trees and that the peaches were ripe, we knew no reason why we shouldn't get some. As each of us wore little blouse shirts, we stuffed our shirts full of peaches and back to the pond we went. While we were resting, after eating all the peaches we could hold, who should come walking up the road but Bill Penley himself. By the way, he knew our families well. His first remark was, "Have you boys seen anyone walking by this way in the past few minutes?" Our answer being "No," he then said, "Well, I'll just keep walking and evidently I'll find their dead bodies in a ditch farther up the road. Somebody robbed my peach orchard and they just happened to get the peaches from the tree I poisoned. Goodbye, I'll be seeing you later..."*

*Well, of all the frightened boys you've ever seen, we got home quickly as possible and told our mothers what had happened. All of us not only had Dr. Neff in to see us, but got a sound spanking besides when Dr. Neff advised our parents we were all right. Of course, Mr. Penley had told us the peach trees were poisoned in order to scare us to death—and he just about did.*

As Garnet and Mary Lynn, the oldest children, reached high school age, the family moved back down the mountain to be near the school. By this time, James Carter had given up his career of

selling on the road and ran a wholesale novelty and cigar business in Chattanooga.

Garnet got his first taste of the tourist trade at the age of sixteen. Two events coincided to bring this about. As stated earlier, Point Park and the battlefield at Chickamauga were declared official military parks in 1898; that same year, the Spanish-American War broke out, and fifty thousand army troops were stationed at Chickamauga Park. Not only did these soldiers bring more money into the area, but their visiting families became tourists as well. Garnet Carter was on hand in 1899, operating a souvenir stand at the park. It was a business he would come to know intimately.

By the turn of the century, Garnet was establishing himself as quite a super salesman, working for N. Dietzen and Brothers, a Chattanooga wholesale grocery house. Papa James Carter received an offer he couldn't refuse when a Cincinnati friend, who also happened to be in the wholesale cigar and advertising premiums business, asked James to come take over his company. This time the family moved without their eldest son, as Garnet was now making a living on his own. He had joined another company and was selling candy wholesale through all of the small towns within a 150-mile radius of Chattanooga.

During Garnet's traveling salesman period, another vitally important part of his future made its appearance. In either 1901 or

Promoter extraordinaire Garnet Carter lived on Lookout Mountain since childhood and was largely responsible for developing the peak for tourists. *Rock City collection.*

1902, he happened to be in the little town of Cowan, Tennessee, and met Frieda Utermoehlen, daughter of a respected violinist. She was a talented musician and artist herself, but at the time she was employed at the Franklin House, a hotel operated by her grandparents, William and Sophia Boucher. Grandpa Boucher's health was failing, so Frieda had pretty much taken over his task of sitting outside the hotel's dining room and collecting for the meals.

Details of the courtship between Garnet and Frieda have been obscured by time. It is known that when Frieda was not on duty at the hotel in Cowan she was at home in Johnson City, and a great many letters from Garnet from a great many places across the land arrived in the two Tennessee towns. One thing is certain: at some point, Garnet must have proposed because the two sweethearts were married on November 15, 1905, in the parlor of the Utermoehlen home in Johnson City.

It wasn't long thereafter that the newlyweds joined the rest of the Carter family in Cincinnati, where Garnet entered his father's wholesale novelty business. For the next five years or so, Garnet traveled the nation selling cigars, premiums and novelties. Around 1910, the family returned to home base in Chattanooga, this time for good.

After the return to Tennessee, Garnet left his father's business and formed his own company to market his seemingly endless

They say that behind every great man is a woman, and in Garnet Carter's case it was his wife, Frieda, who first began the development of Rock City as a private garden. *Rock City collection.*

parade of ideas. His first brainstorm was connected to a business phenomenon known as the profit-sharing coupon. As a sort of forerunner of trading stamps, employees of various companies would receive these coupons as rewards for their hard work, and the coupons could then be redeemed for assorted merchandise. Carter's new twist to this established program was aluminum cookware.

Aluminum had become economically feasible to produce only a few years earlier, but in that short period of time, housewives who had had an opportunity to use it found that the ultra-light material was light years removed from bicep-building, old-fashioned, cast-iron cookware. In one year, the future mayor of Rock City had sold $3 million worth of the new cookware, and the factory in Wisconsin had to install a separate post office just to handle the orders.

Unfortunately for Carter, profit-sharing coupons lost much of their novelty value by the early 1920s. It would seem to become a pattern in Carter's life, as we shall see, that his successful business ventures were often tied to fads. When the fad ran out, Carter was forced to look for a new pasture in which to graze. The one he found after the profit-sharing coupons rush was to have more far-reaching implications than he ever would have imagined at the time. Brother Paul told the story of just how Garnet latched onto something big:

> Garnet and Oliver Andrews, a friend of his who was in the wholesale paper business, both heard what great opportunities there were in Florida real estate. So about 1923 they decided to take a trip down there to see what it looked like. Well, while they were down there some of those land boys sold Garnet and Oliver a lot apiece that hadn't even gotten out of the water yet. When they were coming back up on the train they both saw what fools they were. Garnet said, "Here we are coming to Florida and letting them sell us a $5000 lot in the water, not even up. We must be crazy—but why can't we do something like that in Chattanooga?"

Upon returning to the old hometown, Carter and Andrews began looking around for real estate. They realized that they would have to purchase land that was priced as being comparatively worthless

and then make their money by selling it to wealthy buyers, just as was being done in Florida. At last, the two land speculators found it: approximately three hundred acres of property straddling the Tennessee/Georgia state line. And the dirt was dirt cheap because it sat on top of rocky, almost inaccessible Lookout Mountain.

Because of Frieda Carter's interest in and love for the classic fairy tales that had been told for generations, Garnet christened his planned residential section "Fairyland." As the first real development of any kind on the top of the mountain, the project attracted much newspaper coverage even before the first lots were sold. One article gave a thorough description of the as-yet-nonexistent neighborhood:

> *Fairyland will commence on the eastern part of the mountain near what is known as the "college grounds," and will extend to Chickamauga bluff. College grounds was so named from the old Roberts College which flourished there before the war. There are a few evidences still left of the foundations of the building. College grounds will be the real entrance to the subdivision. It is a quite level tract of a number of acres, sloping gradually to the brow. The view from the bluff at this point is magnificent.*
>
> *Going south from college grounds, along the brow, the present trail follows some gentle undulations until it reaches Rock Village. Nature has been lavish with its beauties here. Both it and Rock City are similar in type. Rock City, just south of Rock Village, is of more elaborate structure. Here the uppermost sandstone bluff has been largely washed clear of earth and vegetation. There are wide stretches of rock with now and then an intervening fissure. The view from Rock City is one of the most entrancing on the mountain.*
>
> *College grounds, admirably suited for such a purpose, will be developed into a nine-hole golf course. Any buildings which will be put there will be built of sandstone and designed so as to harmonize with the surroundings. It is expected further to preserve Rock Village and Rock City as parks.*

The first lots in Fairyland would go on sale December 6, 1924. The method for this sale was the most attention-grabbing that

FAIRYLAND INN
"ATOP LOOKOUT MOUNTAIN"

I T was no wave of a magic wand that transformed a mountain wilderness into Fairyland. But so quick, so complete, has been the transformation that almost magical results have already been achieved.

Yet Fairyland is still at the threshold of its real development. As it stands today, it is only a promise of the greater Fairyland of tomorrow. It still offers a splendid opportunity for investment. While land prices have naturally increased since the first sales were made, they are still at a ground-floor level. Consider the values behind them, and the signs that point to the certain increase that is just ahead.

Fairyland is divided into three sections. The first section was opened in January, 1925. By the middle of August it was entirely sold. Three-quarters of a million dollars was invested by home-seekers and investors—not only Chattanooga people, but residents of many other cities.

𝔉𝔞𝔦𝔯𝔶𝔩𝔞𝔫𝔡
WHERE SPRING SPENDS THE SUMMER

In late 1924, Garnet Carter began selling lots in the proposed Lookout Mountain residential development to be known as Fairyland. *Rock City collection.*

Carter and Andrews could devise. The lots in the subdivision were assigned numbers, which were subsequently put into a hat. Buyers who had plunked down their $2,750 apiece for property would have to draw a number before they would find out just where their lot was located. Some reports say that on the morning after the first sale, the crest of Lookout Mountain resembled something akin to a giant Easter egg hunt, as property owners, clutching their numbers, went scurrying through the forest as they searched for their land.

Not uncharacteristically, Garnet Carter was one landowner who did not have to guess at the location of his land. He had reserved the entire Rock City grounds and some adjoining property for himself—a move that would prove to be immensely valuable to him in the near future.

In the meantime, though, Carter was concentrating on his residential Fairyland. Branch offices of his company were established in Miami and Atlanta, and soon people from all over the South were clamoring for a home on Lookout. Carter employed a unique tactic known as "reverse selling." When an interested customer

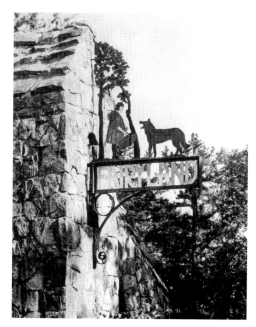

This ornate sign, which denoted the Fairyland neighborhood, would later find a permanent home over the entrance to Rock City's Fairyland Caverns. *Rock City collection.*

approached him, Garnet would apparently try his level best to talk the prospective buyer out of the deal. He would point out the rockiness of the land and any of a half dozen other disadvantages he could think of, until the poor soul was practically begging Carter to sell the land to him. At that point, Carter was free to move in for the kill, as it were, and name his own price. (Some say that he learned this tactic from Br'er Rabbit's methods of operation in the briar patch.)

However unorthodox the sales methods may seem, by all reports the residents of Fairyland were uncommonly happy in their new homes. The posh Fairyland Inn hotel opened with much royal fanfare on June 23, 1925, and the long-awaited golf course was under construction. Carter's partner, Oliver Andrews, sold his half of the business at the end of 1926, leaving Garnet as the undisputed king of Fairyland.

Frieda Carter kept her hands in the development of the area as well. Some years earlier, she had received a miniature drafting kit as a gift and had proven to be so adept with it that her grandmother

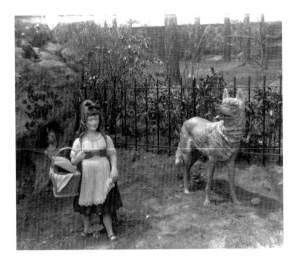

One of the most unusual aspects of the Fairyland development was its inclusion of imported German statues of gnomes and famous storybook characters scattered throughout the grounds. *Rock City collection.*

had gone on record as saying that if Frieda had been a man, she could have made a terrific living as an architect. Such chauvinistic statements notwithstanding, Frieda demonstrated her architectural (as well as artistic) ability by designing a gas station and several of the homes in Fairyland. She was also responsible for another unique feature of the neighborhood: a large collection of statues of elves, gnomes and various fairy tale characters imported from Germany. The figures were set at strategic locations throughout Fairyland.

Perhaps inspired by his wife's efforts and interests, Garnet Carter was toying with an idea of his own. The Fairyland Golf Course was taking longer to construct than originally planned—the top of Lookout hardly had the sort of topography that was conducive to the building of golf courses—and the visitors and residents were getting antsy. Carter responded to this need by building the world's first miniature golf course.

This was not a totally new idea. Several entrepreneurs had constructed putting greens before this, and two of them, Thomas Fairbarn and Robert McCart, had even gone so far as to patent the "perfect surface" for such greens, a strange mixture of cottonseed hulls, oil and dye. However, Garnet Carter was the first to see miniature golf as an amusement of its own, rather than just a practice green. He added to the game's challenge by devising various

ingenious hazards that would help or impede the progress of the golf ball. Newspaper cartoonist Rube Goldberg, who was famous for his eccentric and complicated inventions, gave the following fanciful, but typical, account of how Carter arrived at this idea:

> *The legend runs that he used to practice driving golf balls off the top of the mountain into the valley below. He would station a caddy four miles away and drive 40 or 50 balls off the summit of the mountain every night before dinner. By the time the caddy found the balls he had a long white beard and was too old to climb back up the mountain, so Mr. Carter would never hear from him again.*
>
> *This made Mr. Carter feel pretty bad. He had one golf ball left and sincerely believed that his golf days were over. He sat disconsolately on a pile of debris behind the inn which he ran, and his eyes filled with tears. He looked at the last ball and felt like a father who was sending his only son out into the world.*
>
> *The junk pile that encompassed him consisted of old sewer pipes, empty tomato cans, thousands of broken oyster shells, bits of catsup bottles, ancient straw hats, castaway corsets, old pill boxes, mildewed shoes, scraps of Confederate Army uniforms, and the skeleton of a prehistoric fish. Mr. Carter, lapsing into a melancholy reverie, let the ball drop from his hand. It fell into the mound of refuse and a strange thing happened. The little pellet started on a miraculous course through pipes and over garbage, bouncing back and forth from oyster shell to pill box, ducking coyly into a dilapidated shoe, coming out of the big toe, tripping lightly around the brim of a forlorn straw hat, sauntering leisurely across the face of the petrified fish, leaping madly into the air through the hole of a discarded doughnut and, trickling sedately back, finally dropped into the open mouth of the disconsolate Mr. Carter. He awakened from his trance with a start, and miniature golf was born!*

Carter had a name for his game—Tom Thumb Golf—and he made it fit the rest of the Fairyland décor by dressing it up with his now-famous gnomes and elves. The game caught on with its

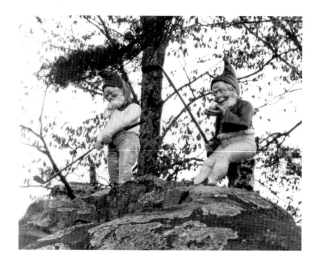

Garnet Carter's Tom Thumb Golf, adjacent to his Fairyland Inn, is today acknowledged as the nation's first true miniature golf course. *Rock City collection.*

participants, and soon Carter was compelled to take out a patent and begin a franchising program. The Fairyland Manufacturing Company was established to produce hazards, signs and other paraphernalia, and the prefabricated courses were soon being set up on seemingly every vacant lot in America. It appeared that the entire country had "Gone Goofy Over Miniature Golf," as a song of the day put it, and Carter found himself once again turning a fad into a fortune.

While Garnet was puttering around with Tom Thumb Golf, Frieda had not been ignoring the crowds who were flocking to the Fairyland Inn to play the game on the original course. With these tourists in mind, she was responsible for the concept and design of two new features. One was designated Hansel and Gretel's Gingerbread House, a log building that, as the name implied, sold fresh gingerbread and other refreshments and souvenirs. Frieda's other major contribution was Mother Goose Village, a group of ten homes with nursery rhyme–inspired names and elaborate wrought-iron nameplates.

By now, once-sleepy Lookout Mountain was swarming with activity. In 1928, spelunker Leo Lambert conceived the idea of opening an old cave at the base of the mountain as a tourist attraction and, obtaining some property on the mountainside,

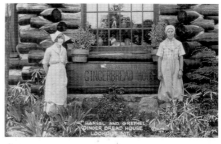

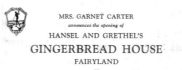

Frieda Carter demonstrated her abilities as an architect by designing the Gingerbread House, a snack and gift shop in Fairyland. *Rock City collection.*

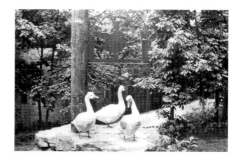

A subdivision of Fairyland was known as Mother Goose Village. This signage and these artificial ganders were situated at the entrance. *Rock City collection.*

Among the many other characters one could meet in Fairyland were Br'er Rabbit and his wife. Like most of the others, the bunny buddies would later find a home in Rock City. *Rock City collection.*

began drilling an elevator shaft. Before reaching the intended cave, however, the workers unexpectedly broke through into a previously undocumented cave that was located above the one they were seeking. This one turned out to contain a gigantic underground waterfall, which Lambert named Ruby Falls in honor of his wife. Stone that was removed during the drilling of the elevator shaft was used to construct an entrance building known as Cavern Castle. Ruby Falls would be formally opened to tourists on June 16, 1930.

Garnet Carter's younger brother Paul also wanted to get in on Lookout's newfound popularity. He built the fabulous Lookout Mountain Hotel, which received its first guests in June 1928. Visitors at the hotel were eligible to use the nearby Fairyland Golf Course (which had finally been completed), but there did arise a comical, good-natured rivalry between the two brothers and their respective resorts. Chattanooga newspaper columnist Verne Prater gave a somewhat exaggerated report on the competition, which reads almost like a scene out of a Bob Hope/Bing Crosby movie:

> *These boys can help each other out. You see, if Paul has a house full of guests and Garnet wants some of them, Garnet can go up to Paul's hotel and try to sell his guests a lot. They will all get mad and go to Fairyland. Then Garnet can follow them down to his hotel and tell them if they don't buy a lot he will throw them out. You see, they have no other place to go.*
>
> *These Carter brothers are figuring on making the old Johnson Pike a one-way road next summer, and that will be going up. Once on the mountain, you will be there all season. If they go down the Incline, Garnet and Paul will have their automobile for the first payment on the lot.*
>
> *Garnet figures he has the advantage of Paul. He says he will be in a position to feed the guests cheaper, as he is married and his wife can do the cooking, but Paul comes right back and says he won't have to hire a clerk as his Papa Jimmie will do the clerking and sell the cigars. Paul also says his hotel is up so high and out of the smoke and dirt, he won't have to change the sheets but once a month, but Garnet gets by that by using rubber sheets, and hangs them out on rainy days.*

*Garnet says he will furnish the bus line for his little brother Paul. Garnet plans to have his bus run out of gas at Fairyland and unload all the fine feathered birds from up north, then take all the pelicans from Florida up to Paul's hotel. Paul says he won't need any writing paper, for he is going to make everyone pay cash in advance. He won't have to send out any bills, and all his guests will be having so much fun they won't want to write home. Garnet says all his guests, after he gets through with them, won't have enough money to write home. So you see, it's going to be a fight to the finish between these brothers.*

As everyone knows by now, those heady days could not last forever. In October 1929, the country was suddenly plunged into the worst depression it had ever known. Tom Thumb Golf managed to survive in spite of economic woes; in fact, the need of the populace for an inexpensive form of entertainment contributed to its boom during these years.

The luxury resorts on Lookout were adversely affected, indeed. During 1930, both the Fairyland Inn and the Lookout Mountain Hotel locked their doors. All Garnet Carter had now was Tom Thumb Golf and a piece of property with some crazy giant rock formations on it. How was he ever going to survive the Depression with ridiculous resources like that?

He made a way, that's how.

## Chapter 2

# A ROCK GARDEN TO END ALL ROCK GARDENS

As 1929 faded into 1930, any partygoer who dared to say "Happy New Year" would probably have been branded as either a wishful thinker or a notorious liar. Truly, there was very little to be cheerful (or even cautiously optimistic) about. Unemployment was growing at an alarming rate each day, as more and more businesses were forced into bankruptcy by the Depression's cumulative effect. One of the only companies to be making money during this bleak year was Tom Thumb Golf.

One might be tempted to think that Garnet Carter would be completely satisfied to have one of the few prosperous companies of the day, but that was not the case. One of the main reasons was that, despite Carter's patents and copyrights, enterprising entrepreneurs all over the nation had made a lucrative business out of copying the Tom Thumb game. Seemingly every vacant lot now sported either a genuine or ersatz miniature golf course, and the public was flocking to them as if it had nothing better to do. (Being out of work, many of them probably did not!) But Carter had learned from his past experiences, most notably from the profit-sharing coupons/aluminum cookware fad. He realized that any craze had only a limited amount of time before the public would become weary of it, and the proliferation of imitators would only help to hasten this inevitable process. Therefore, he determined to unload Tom Thumb Golf while it was still making a healthy profit.

Carter traveled to Pittsburgh to look for a prospective buyer. The one he eventually found was H.H. Patterson, heir to the Heinz

pickle empire. Carter dragged out his famous "negative selling" technique, and it turned out to be as effective as always. He quite honestly told Patterson that, for all practical purposes, Tom Thumb was dead, but Patterson would hear none of that. "You know this thing could blow up," Carter told him. "People are fickle. What amuses them one time won't amuse them another."

By now, Patterson was irrevocably in Br'er Carter's clutches. The deal went through, and Garnet Carter found himself $200,000 richer. He also retained ownership rights to the original Tom Thumb course at Fairyland. Carter decided to use his newfound wealth to make some shrewd investments, and on the advice of some financial experts he sunk most of his money into a reliable company, U.S. Steel, whose stock was going for $298 per share. It was unfortunate that U.S. Steel turned out to be one of the worst casualties of the Depression. Before Carter could say "hey, brother, can you spare a dime," U.S. Steel stock had dropped to $30 a share, and Carter felt he could have accomplished much the same thing by tossing his $200,000 into a vat of molten metal.

While Garnet was busy losing the family fortune, his beloved wife Frieda had quietly begun working on a project of her own, with no fanfare whatsoever. She decided to take their bizarre Rock City property and turn it into a rock garden to end all rock gardens.

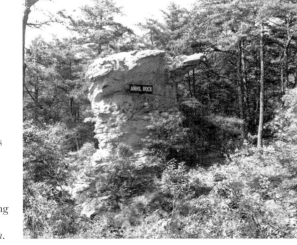

One of the first sights visitors to Rock City encountered was Anvil Rock. It is also a sight that no one will see today, as it sat where the parking lot now exists. *Rock City collection.*

Ever since Fairyland had first opened to visitors and residents, Frieda had noticed their interest in exploring the "city of rocks," and that became her starting point.

With the help of two Fairyland employees, Orville York and Don Gault, and a personal friend, Annie Penley, Frieda began the development of Rock City. She took some string and marked a trail leading to the large rock outcropping known variously as Lover's Leap and Steamer Rock (because of its resemblance to the prow of a ship jutting out from the mountainside). Reaching this spot called for a rather strenuous climb around the formation's back side, so to make it more accessible to the average tourist, Don Gault devised a swinging bridge built of leftover cables from the Incline Railroad. The trail was surfaced with pine needles and pebble gravel.

Frieda collected wildflowers and other plants and had them replanted along her trail. The total effect was such that it appeared as though the flowers had always grown there, and to this day many people are prone to forget that Rock City Gardens is indeed a garden, in every sense of the word.

Shortly after Frieda began her project, she made the disturbing discovery that her right shoe was wearing out faster than her left. Her limp worsened, and it was not long before she totally lost the use of her right leg. She would later be diagnosed as having creeping

Many of the gnomes that had inhabited the Fairyland neighborhood were moved into the new Rock City development, where they served as interesting diversions along the Enchanted Trail. *Rock City collection.*

paralysis, but it strongly resembled what eventually became known as multiple sclerosis. This personal tragedy may have been the greatest turning point in the history of Rock City.

Garnet Carter, because of his tremendous love and respect for Frieda and her ideas, began to take a second look at what she was doing in her oversized rock garden. The idea began to form in his mind that perhaps this was the answer to the question of what to do with his future. Since the real estate business in Fairyland was stagnated by the Depression anyway, and because he was beginning to see economic possibilities in Rock City, he took on helping Frieda with the Gardens' development as a full-time occupation.

Garnet expanded and improved the trail that Frieda had first devised, replacing the pine needle and gravel surface with stepping stones. Many of the gnomes and statues of storybook characters that had populated the Fairyland neighborhood and the Tom Thumb Golf course were carted to Rock City and placed in the new surroundings. Although the property was left in its natural state as much as possible, a few improvements on Mother Nature were silently made. A crevice underneath a large overhanging rock was filled in to make a floor, and the resulting grotto was dubbed Shelter Rock. Some passageways were widened slightly to make the path easier to navigate, and other passageways were actually blasted through the solid rock to make shortcuts.

A small, round building with a conical roof was built at the entrance to the gardens. Known as the Sugar Loaf Shop, the tiny structure doubled as an office for Frieda and a souvenir stand. Among its earliest pieces of memorabilia offered for sale were a number of black-and-white postcard views of scenes in Rock City, produced by the Walter Cline Studio, a well-known Chattanooga photography company.

While working to make Rock City accessible to all, Garnet Carter might have had second thoughts about so hastily unloading Tom Thumb Golf, which now seemed like such comparatively easy money. Any such thoughts were dispelled in 1931 because, during that year, the fickle public dropped the miniature golf fad as quickly as it had picked it up a few years before. Market saturation was blamed for the game's early death, and while miniature golf would

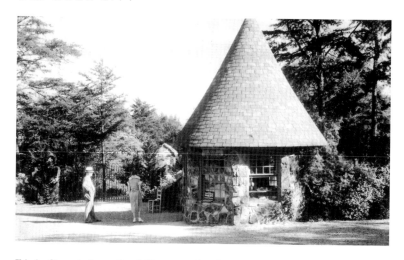

Frieda Carter's Sugar Loaf Shop served as Rock City's entrance building from 1932 to 1937. The structure currently serves as a museum of Rock City artifacts. *Rock City collection.*

indeed make a comeback in the vastly different world of the 1950s, it would never again produce the out-and-out mass hysteria of its first round. Carter must have breathed a sigh of relief when he realized he had gotten rid of Tom Thumb just in time.

Also in 1931, the Fairyland Inn was sold to a group of investors from Atlanta. Although at the last minute Carter tried to change his mind and buy back the property, the Atlantans outbid him by $500. He was now more in need than ever to make Rock City a success. (The hotel was reorganized as the Fairyland Club in 1934. Today, it remains a private club for residents of Lookout Mountain.)

Little if any attention was given to the changes that were slowly taking place in the rock city. In fact, the first mention of the work appeared in the newspaper on February 17, 1932, in a tiny article headlined "Rock City Beautified by Fairyland Company." The entire text read:

> *Garnet Carter, president of the Fairyland company, is beautifying Rock City, a section of rocky mountainside south of Fairyland Inn, and after two or three months' work, with an expenditure said to amount to several thousand dollars, has turned the area into a park.*

*Flower beds have been planted, benches have been built and placed at various points in Rock City, and winding walkways have been constructed. The development is part of the residential section on Lookout Mountain that Mr. Carter promoted.*

An opening date of May 21, 1932, was announced, and during the preceding weeks the Chattanooga newspapers were inundated with a flurry of promotion that would come to be traditional for Rock City. Contests were conducted to name the Gardens' sights that did not already have names, and the winners of these contests were awarded the tremendous sum of one dollar (in 1932, when people were begging for dimes, that wasn't a little).

On May 8, 1932, the music and art writer for the *Chattanooga Times*, Ruth Faxon Macrae, wrote the following, the earliest extant description of the original Rock City trail:

> *The enchanted trail takes us through tunnels and over bridges on the heights and down to the bottom of Rock City. Many stone stairways have been built, adding ease and comfort to the long trail. We pass Pulpit Rock and wiggle through Fat Man's Squeeze. We see the Eye of the Needle, the Grand Corridor, Shelter Rock, Lover's Leap, Tortoise Shell Rock, Pedestal Rock, and on to the Lion's Den.*
>
> *In the dainty fairy-ring down deep in a cavern we hear soft whispers of elves and fairies. We pass Galoochee, the old witch stone, and reach the Ship Rock, moss covered and gray with lichen, ready to bear us away to a distant land.*
>
> *Many gnomes add to the charm, the mystery and the interest of the place. On a wide platform under an overhanging rock, an orchestra of gnomes stands ready to play fairy music. Other gnomes serve as guides, standing at points of interest along the trail to show the different locations. On a shadowy slope within the caverns sits Rip Van Winkle, awakened from his nap of twenty years, watching in a dazed fashion the gnomes as they roll their ten pins down the hill. In a barberry thicket, Red Riding Hood and the wolf converse pleasantly.*
>
> *There are three cable bridges spanning the chasms. The longest, 100 feet long, swings out over the Cave of the Winds,*

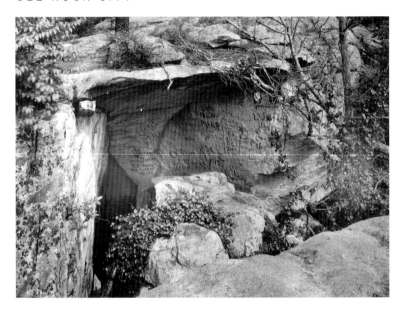

These two photos show how Garnet Carter and his workers improved upon nature. *At top*: Shelter Rock as it looked before any development, complete with early 1900s graffiti. *At bottom*: In 1932, the formation had received a set of musical gnomes, but it was still too dangerous for tourists to venture under it. *Rock City collection.*

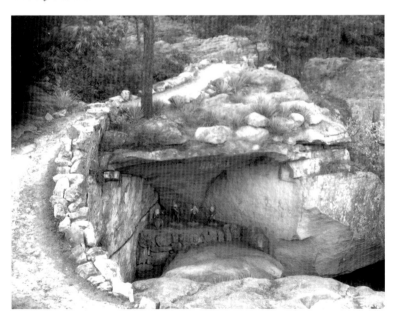

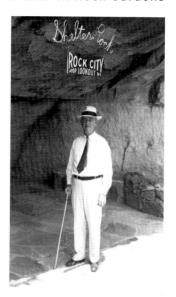

Garnet Carter posed for this publicity photo under Shelter Rock, which had finally received a solid floor for the benefit of visitors. *Rock City collection.*

> *reaching from one high bluff to another. Two tunnels have been made, thirty and sixty feet in length, ready to take us through masses of rock to interesting places beyond.*

In an article in the city's other daily paper, the *Chattanooga News*, on May 13, Carter perhaps gave a hint as to why he was willing to let Rock City be known as the culmination of his life's work: "They can't copy me now like they did on the Tom Thumb golf course," he told reporter Nellie Kenyon, "and I won't even have to take out a patent. We have something here that cannot be reproduced by man." The article closed with a preview of things to come:

> *While many improvements have been made in the grounds during the past twelve months, Mr. & Mrs. Carter have only begun to carry out their dreams for improving this property. A large plaster lion has been ordered from Germany to add a more realistic touch to the den, and a miniature still will be set up in one of the large rock chambers with dwarfs appearing in the roles of moonshiners. Hundreds of additional plants will be planted in the gardens and many other improvements will be added from month to month.*

On opening day, the first guests to be admitted were the members of the Lookout Mountain Beautiful Garden Club, in which, naturally, Frieda Carter was not just a little active. Among the visitors in that group was seven-year-old Martha Bell Miller, whose mother and grandmother were both members of the garden club. Six decades later, Miller remembered that on opening day Garnet Carter greeted the club members at the entrance and presented each of them with a small pencil sharpener shaped like a gnome. Miller kept her gnome as a memento until the little plaster of Paris figure finally disintegrated. (Martha would literally "play a part" of her own in Rock City's history during the 1980s, but that story will come later.)

Almost exactly one year after the formal opening of Rock City, at a meeting of the garden club on April 7, 1933, Frieda Carter was presented with an honor that would become a proud part of Rock City's advertising for years to come. The Garden Club of America awarded her the Horticultural Bronze Medal of Distinction for her "conservation and unusual development of Rock City in Fairyland." It was said that she was the first Southerner to be given this honor.

Not content to rest on their laurels (just one of the many types of flowers that had won Frieda the garden club award), the staff continued to make improvements in Rock City. By September 1933, one of the Gardens' most famous and enduring sights had been installed: the Moonshine Still, presided over by a horde of the colorful imported dwarfs. Publicity releases indicated that a still had actually been found in that particular cave years before, but whether it had been operated by gnomes or simply some enterprising human mountaineers was not specified.

In today's world, where the tourism business is a billion-dollar industry, it is difficult to realize that at the time of Rock City's opening, highway travel was so limited that a "tourist attraction" was almost unheard of. There was no one to whom Garnet Carter could turn for advice when he needed it. Well, almost no one. There was at least one tourist kingpin that had preceded Rock City, and that was Florida's Silver Springs (of glass-bottom boats fame). Since the early 1920s, Silver Springs had benefited greatly from the promotional abilities of its owners, David Ray and Shorty Davidson,

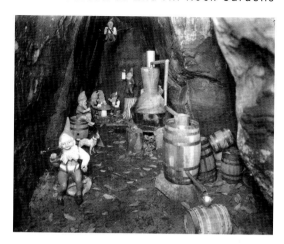

Rock City's Moonshine Still diorama was one of the earliest and most durable man-made sights in the gardens. It has survived in its small cave since 1933, although age and neglect have dwindled its once-large cast of alcoholic elves down to two. *Rock City collection.*

and now Garnet Carter found himself journeying to Ocala to visit and seek advice from these Southern tourism pioneers.

This trip was indeed educational for Carter. Since tourist courts (later known as "motor courts," "motor hotels" or simply "motels" for short) had yet to develop their eventual prominence, Carter spent his time in Ocala at a tourist home, a type of boardinghouse that was doing business only because of the crowds being lured in by Silver Springs. Paul Carter later recounted his brother's story of what transpired down in the Sunshine State: at dinner, Garnet asked the lady who owned the tourist home what she personally thought of Silver Springs. Her reply nearly made him choke on his biscuit and grits. "Oh, it's all right, I guess," she yawned. "It's just a bunch of water. You go out there and look down in a boat. It's nothing special; there are springs like that all over Florida."

The lady was correct about Florida's abundance of springs, but Carter still found it inconceivable that such blasé remarks could come from someone who was making her living strictly because of Silver Springs, and he reported the incident to Shorty Davidson the next day. "Shorty, what in the world do you do about something like this?" Garnet asked.

"Well, Carter," Davidson said as he leaned back in his chair, "I just pray for them."

During that same visit, Davidson gave his Rock City colleague another valuable piece of advice: "Good advertising is fine," he said, "but even bad advertising is good." Carter took that concept to heart, and Rock City became the most publicity-conscious of all tourist attractions. At the same time, Carter did not forget his experience in the tourist home, and in the future, motels would become some of Rock City's most valuable outlets for advertising.

By the mid-1930s, the country was slowly but surely pulling itself out of the Depression. People began to travel more, partially helped along by the road improvements made by President Roosevelt's Works Progress Administration program. Tourist cabins became more popular, and some of the earliest chain restaurants (most notably Howard Johnson's) began to spring up to cater to the increasing number of automobile travelers. Rock City benefited from this trend, as well, and as its fortunes improved, it was able to upgrade its facilities.

One day, a caretaker in the gardens became interested in a groundhog that was burrowing under a certain rock. The workers began digging up the burrow, and when all the dirt was cleared away, the famous 1,000-Ton Balanced Rock was revealed in all its teetering glory. Since no one was certain that it was balanced

This top-heavy formation was known as Balanced Rock when Rock City opened in 1932—as evidenced by the sign the gnome is holding—but after the much larger 1,000-Ton Balanced Rock was discovered, this one became today's Mushroom Rock. *Rock City collection.*

permanently, Carter let it stand for a year before he would allow anyone to go near it. After that, however, it became a regular part of the tour. Another rock that had previously been referred to as Balanced Rock was renamed Mushroom Rock (which is actually what it had more closely resembled all along).

In 1935, the first color Rock City postcards were produced by the Curt Teich Company of Chicago. The Teich artists would begin with the traditional black-and-white Walter Cline photographs but would then "colorize" them, long before TV mogul Ted Turner thought of the concept. Unwanted details were painted out, and at other times, nonexistent details would be added. The cards were splashed with colors not normally seen in any type of reality, but no one seemed to care. Their garish look had a charm of its own and must have been a welcome relief from the drab black-and-white photo cards of earlier years.

When the Curt Teich company went out of business in the 1970s, its records became the property of the Lake County Museum in Wauconda, Illinois. Among these artifacts is some production material on a handful of the Rock City cards. It gives an excellent idea of the procedure through which a black-and-white Cline photo became a color Teich postcard. As an example, let us use the famous Moonshine Still, one of the earliest cards Teich produced for Rock City.

As usual, Teich began with an eight- by ten-inch photo of the diorama. The production notes show that Garnet Carter ordered six thousand Moonshine Still cards on July 3, 1935. Under the heading of "color description" are probably some of the most detailed instructions ever given for a postcard, Rock City or otherwise: "Dwarfs are a vivid coloring. One has green vest, brown pants; other yellow pants and blue vest; another has green pants, white vest; all have red caps. Cave walls natural rock. Still is dull copper color. Barrels natural wood. Moss (very little) on ground." The instructions also told the artist to paint in a fire under the still, where nothing existed in real life.

After receiving these directions, the overworked and underpaid Curt Teich artists would set about heavily retouching and coloring the black-and-white photo. The result was a sort of hybrid

photograph and painting, which would then be reproduced by the thousands on postcards.

(In the production materials for other Rock City Teich postcards, the most common instruction was for the colorist to make the foliage "look like the fall of the year," regardless of when the picture was actually taken. Also, directions consistently warned to leave the rocks their natural color, but this the company apparently ignored, as often the cards show stones with blended colors of purple, pink, yellow, red and other decidedly un-rocklike hues.)

The postcards and other ads of this period made quite a big deal out of the fact that five states could be seen from Lover's Leap (for the uninitiated, the states were Tennessee, Georgia, Alabama, North Carolina and South Carolina). However, across the mountain at Point Park, much publicity was being given to the claim that *seven* states could be seen from Umbrella Rock, the additional states being Kentucky and Virginia. Not to be outdone, Rock City soon upped its state count by two, and "See Seven States from Rock City" became such a famous slogan that soon very few people remembered that Umbrella Rock had used it first.

On March 13, 1935, the first Rock City souvenir booklet was released. Little is known about it, except that it contained

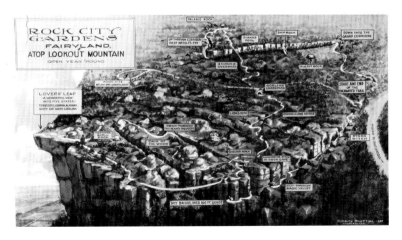

This mid-1930s artwork depicts the route and principal features of the original Rock City trail. Notice that Lover's Leap was the vantage point for seeing into five states. *Rock City collection.*

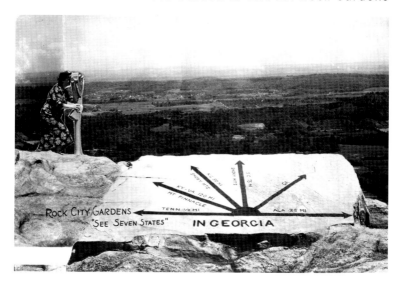

Because tradition had it that Mount Pinnacle, on the Kentucky/Virginia border, could be seen from Lookout Mountain on a clear day, Rock City soon changed its slogan to the more famous "See Seven States." *Rock City collection.*

comments pulled from the visitors' register. These tributes came from tourists representing all parts of the United States, proving that Rock City had an appeal that was not limited to any specific geographic area. Still, Garnet Carter realized that he needed some sort of concentrated advertising program to pull in more of those travelers who were taking to the highways in increasingly great numbers. He was just not certain how to go about implementing such a project. At this point, into the picture came a young man named Clark Byers.

The twenty-one-year-old Byers had worked at a variety of odd jobs before joining Chattanooga's Southern Ad Company, a sign-painting firm. His wages of seven dollars per week were such an increase over what he had been making at his previous jobs that he frequently found himself working through his own lunch breaks, overwhelmed by his own enthusiasm.

This zeal was not lost on Byers's boss, Fred Maxwell, who was a good friend of Garnet Carter. Maxwell and Carter had apparently already been discussing advertising possibilities because, one day

in 1936, Maxwell asked his enthusiastic young employee to come along with him for a drive. "I didn't know where we were going," Byers said later, "but we got to talking about painting ads on barn roofs, and Mr. Maxwell said, 'If I ever get Garnet Carter started on barn roofs, he'll paint them till his whiskers get down to his belt.'"

Maxwell introduced Byers to Carter, and the three of them made an agreement that Byers would paint barn roofs with Rock City advertisements, at forty dollars per roof. At first, Carter and Maxwell chose the barns they wanted painted and left Byers to work out a deal with the farmers who owned the structures. These owners were usually more than happy with the promise of this free maintenance for their barns, once they found out what "Rock City" was, that is. Byers said that many of them initially thought it was some new brand of beer. In later years, the farmers were paid a nominal fee, never more than ten dollars per year.

The first barn painted by Byers was near Kimball, Tennessee, on U.S. Highway 41 (known as the Dixie Highway because it was the primary route used by tourists traveling from Chicago to Florida). Unlike the famous barn roofs to come, the original sign had a red background with white letters and spelled out "35 MILES TO ROCK CITY ATOP LOOKOUT MOUNTAIN." Byers soon became adept at locating prominent barns that had been overlooked by Carter and Maxwell, and before long he was allowed to choose his farmyard canvases on his own.

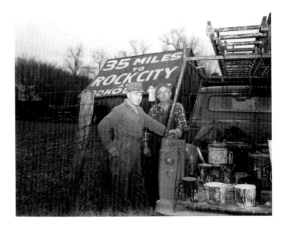

Clark Byers (left) began painting barn roofs with Rock City advertisements in 1935. Here, in 1961, he posed with Cecil Smith (right), owner of that first barn near Kimball, Tennessee. The barn was later demolished for construction of Interstate 24. *Rock City collection.*

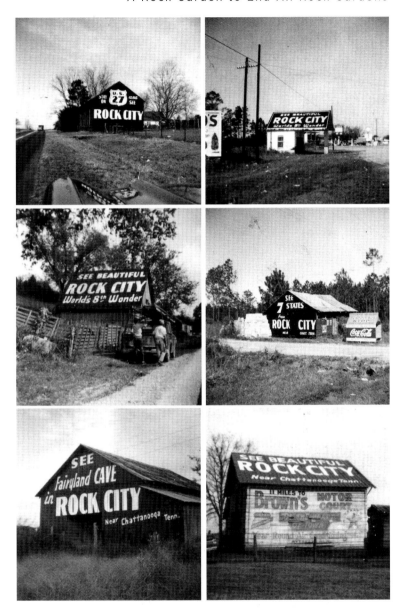

Although the traditional popular culture image is that of a barn with the three words "SEE ROCK CITY" painted on the roof, as these photos demonstrate, rarely was that famous phrase used alone. *Rock City collection.*

The popular public image is that of a barn roof painted with the three words "SEE ROCK CITY." In actuality, those particular words were rarely used alone. Embellishment was common, and Byers's signs ran the gamut from "SEE BEAUTIFUL ROCK CITY" to "SEE ROCK CITY, WORLD'S EIGHTH WONDER," and later, to more elaborate combinations such as "WHEN YOU SEE ROCK CITY YOU SEE THE BEST" and "'TWOULD BE A PITY TO MISS ROCK CITY." In the meantime, Byers had discovered that black paint was much less expensive than red, and his roofs became black with white letters, a color combination that would dominate Rock City's advertising in all media for the next fifty years.

The barns covered the United States as far west as Marshall, Texas, and as far north as Lansing, Michigan. They would become an integral part of the American roadside scene and gave Rock City the boost it needed. The barns also inspired other entrepreneurs to begin experimenting with the medium. Lester Dill, the owner of Meramec Caverns on U.S. 66 in Missouri, was quoted as saying that he was driving through Virginia and Tennessee when he happened to spy some painted barns. He thought this was such a good idea that he returned to Missouri and began having barns throughout the Midwest painted with "SEE MERAMEC CAVERNS" signs. This slogan, and the fact that Dill's barns were painted black with white lettering, leaves little doubt that it was the Rock City barns that gave him his cue. Another rooftop advertiser was the North Carolina–based chain of Sterchi's furniture stores, whose coverage area roughly paralleled that of Rock City.

In May 1937, Rock City got a new entrance building to replace the small, round Sugar Loaf building that had been used up to that time. The new building was again designed by Frieda Carter, showing that, despite her physical problems, her creativity and artistic abilities were as sharp as ever. The building contained enough room for a soft drink stand, a gift shop, the Eat-A-Bite Restaurant, restrooms and office space. Gasoline pumps were installed at one end of the structure. At the same time the new entrance building was being constructed, the Carters were putting the finishing touches on their new home on the bluff next to Lover's Leap. The residence became known as Carter Cliff and would serve as a "president's mansion" of sorts for Rock City in the years to come.

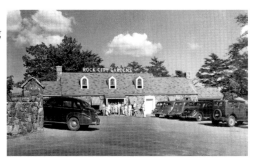

This new entrance building replaced the conical Sugar Loaf Shop in 1937. It still serves as the beginning of the Enchanted Trail today, although the parking lot seen here was converted into a flagstone entrance court in 1946. *Rock City collection.*

With Clark Byers spending every possible moment painting barn roofs with advertisements, Garnet Carter began looking around for other ways to get Rock City's name before the public. Not surprisingly, he came up with another idea. A newspaper article dated October 9, 1937, told the story:

> *One thousand advertising signs have been purchased by Garnet Carter of Rock City Gardens and the Tennessee Electric Power Company. These signs will line the main highway between Chicago and Miami, and will advertise Chattanooga to the world as never before.*
>
> *A truck will leave Lookout Mountain the first of next week to begin distributing the signs between Chattanooga and Chicago, Mr. Carter announced. The signboards are three by four feet and are designed in black and white, reading in big letters, "Visit Chattanooga. See Rock City via Scenic Lookout Mountain Incline. Steepest in the world."*
>
> *As soon as the northern section of the U.S. Highway, No. 41, has been worked, the truck will be sent into Florida and one of these signs will be erected in every county in the state, Mr. Carter stated. The first of these new advertising posters went up this week on the Chattanooga-Atlanta link of the Dixie Highway. They have been placed every three miles along this roadway.*

One week later, Carter made another announcement: he was going to take on the responsibility of reviving the trusty old Lookout Mountain Incline, which had fallen on hard times with the arrival

of the automobile. "I am going to be promotion manager for the Incline, and I am going to put it back on the map," he told reporters. "I am not going to get a cent of pay out of it. We are going to get the people to the top of the mountain and then I am going to get my share of them through Rock City. The tourists are crazy about the Incline. It's the only thing like it in the world."

However worthwhile the plans to revitalize the Incline may have been, they wound up opening a mountain-sized can of worms for Carter and nearly everyone else in Chattanooga's tourist industry. It all started because of the Lookout Mountain guides, an almost forgotten aspect of the area's tourism history today. These guides were stationed in booths at the foot of the mountain and, for a fee, would take the wheel of tourists' cars and handle the driving to the various attractions. These attractions would, in turn, pay the guides a percentage of their profits for bringing visitors to them—but this procedure turned out to have a dark side.

A rather distasteful aspect of Southern tourism was the infamous Lookout Mountain guides, whose booths were stationed at the foot of the mountain to separate tourists from as much of their money as possible. *Rock City collection.*

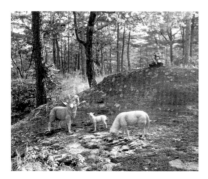

Among the many scenes set up along the Rock City trail in the early days was this set of sheep, plus a horn-blowing gnome, which must have been the world's oldest Little Boy Blue. *Rock City collection.*

The guides would often use questionable tactics to frighten tourists into thinking their expertise was vitally necessary. They especially preyed upon cars with license plates from flatlands states, solemnly stating that the roads on Lookout Mountain were far too dangerous for strangers to attempt on their own. There were also no posted or established guide fees; the guides would simply charge excessive amounts to those visitors they judged to be more prosperous. Then, even though attractions such as Rock City and Ruby Falls were paying commissions to them, the guides would sometimes bypass the places in their hurry to get back to the foot of the mountain and pick up another carload of tourists.

When Garnet Carter took over the Incline, the guides demanded a percentage of its fares, not only because it would be a third Lookout Mountain attraction, but also because it would effectively be taking away a healthy portion of their customers who would otherwise be driving cars. The financially strapped railway was having trouble just staying afloat, so Carter refused to pay.

That did it. For several days in January 1938, the newspapers carried veiled threats from both sides, as the guides found themselves having to protect their business from accusations of extortion. This volatile situation exploded on January 20, when the *Chattanooga News* carried an article under the grim heading "Mountain Folk Declare Open War on Guides":

> *Garnet Carter, developer of Rock City Gardens, nationally advertised Lookout Mountain show place, "declared war" on the guides and with Lookout Mountain Police Chief W.I. Stoner called at the Chamber of Commerce to discuss the situation. It was also revealed that an act for state regulation and control of the guides will be prepared for submission to the next session of the Legislature.*
>
> *"I am out in the open," Carter declared. "I have paid plenty of commissions, but you can say for me that Rock City is not going to pay another commission. I'll close up first. I told the guides that if they love me, they have to love the Incline. Some of the guides told me that if people get to the Incline they will get there over their dead bodies. I told them that there is not enough*

*room for the guides and for Rock City and the Incline, and so it
is a fight to the finish."*

A couple of days later, some of the more prominent guides
announced that they would begin a boycott of Rock City. Perhaps
to save his own skin, Shirmer Brown, owner of Ruby Falls, stated
that he felt Carter's charges against the guides were "vicious and
unjust," and he praised the guides as being public-spirited. One of
the more public-spirited guides boasted, "We took three customers
away from Rock City today, and when the weather is good we will
be taking eight customers a day."

Tourists found themselves caught between Rock City and a
hard place. Disenchanted visitors jumped into the fray, with a
typical complaint running like the following one from a Gulfport,
Mississippi man that was published for all to read:

> *Not only for the city's sake, but for the visitors you have, you
> should curb the activities of these guides as to the prices they
> charge, and see particularly that they tell visitors the truth when
> seeking to sell their services...especially as to the miles and miles
> of roads necessary to travel in going to the mountain if they are
> not employed to show the way. Personally, the way the roads are
> marked, I would have been much better off if I hadn't employed
> a guide at all.*

The battle grew thicker. A family from Philadelphia stopped for
gas in Knoxville and was advised not to visit Chattanooga because
the city had an "epidemic of fleas." Braving the humbug bugs, the
tourists arrived in Chattanooga but did not see any of the Lookout
Mountain sights. The guides warned them that the Incline was
unsafe and described, in horrifyingly graphic detail, the dangers of
all the mountain attractions.

The chamber of commerce stepped in to try to repair the whole
ugly mess. It did so by instituting ordinances that required the
guides to be licensed by the city and to pay an annual privilege tax
of $7.50. This ended the problems temporarily, but as we shall soon
see, this was a conflict that would not easily curl up and die.

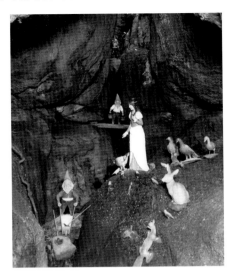

In response to the popularity of Walt Disney's first animated feature, *Snow White and the Seven Dwarfs*, this set of characters was stationed along Rock City's trail in 1938. *Rock City collection*.

Meanwhile, Rock City was continuing its additions and improvements for the benefit of those tourists who managed to elude the guides' machinations. In April 1938, some new figures were imported from Germany to join the already-large collection. The new statues included Snow White and all seven dwarfs. Although they were not designed to resemble the famous Walt Disney versions of the characters, their arrival in Rock City was clearly inspired by the release of Disney's initial animated feature the previous December. The newspaper photo that announced their acquisition captioned them as "favorites of fairy tales and the silver screen."

Having accomplished what he had set out to do with the Incline (that is, getting it up and running again, not making mortal enemies who were determined to put him out of business), in the summer of 1938 Garnet Carter began looking for other tourist-oriented ventures. In May, Carter and four other businessmen announced that they were taking steps to purchase Craven's Cavern on Lookout Mountain and intended to open it to the public. Had this actually come to pass, it would have thrown Carter into direct competition with Ruby Falls, as the new cave also contained a waterfall. At 236 feet high, this waterfall (newly named Mystery Falls by Carter)

would have dwarfed Ruby Falls, but a dispute over ownership of the property on which (or perhaps *in* which) the falls were located proved to be too much. This was another idea that had to be put on the back burner for the time being.

The year 1939 would turn out to be a great one in the United States. It looked like the Depression was finally over for good, and a spirit of optimism reigned supreme. It was the year of *The Wizard of Oz* and *Gone With the Wind*, and Rock City seemed to capture the

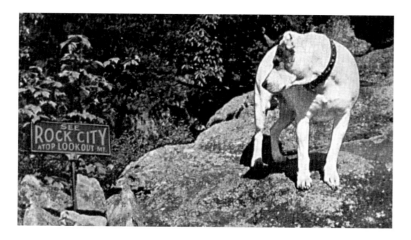

Garnet Carter's beloved dog Spot (top) was the official "mascot" of Rock City during the 1930s. For many years, a statue of Spot (bottom) could be glimpsed as one of the first sights along the Enchanted Trail. *Author's collection*.

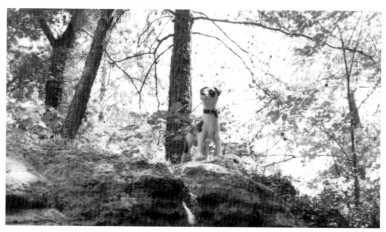

best of both of these entertainment megahits with its combination of storybook fantasy and Southern charm. Oh, across the ocean in Europe there were some rumblings of war thanks to a crazy paperhanger named Adolf Hitler, but few people in America were concerned about that—at least for now.

A flurry of activity at Rock City during March 1939 revolved around a supposed "buried treasure" in one of the attraction's hidden caves. Spurred on by Carter's promise of a fifty-fifty split, treasure hunters converged on the site, digging feverishly for what an old Civil War legend said was buried on the Rock City property. Carter remarked, "A million dollars or a pile of bones…it doesn't make any difference to me, but let's see what it is in there." Bystanders were of the opinion that if it did turn out to be just a pile of bones, Carter would figure out a way to make a million (or at least part of it) from them. Carter responded by saying that if it turned out to be the skeleton of a Civil War soldier, he at least hoped it would be a Confederate one.

But the digging did not last long because the workers soon struck a large boulder that had slipped to block the entrance to the cave sometime during the intervening years following the war. The only artifacts that were recovered were some "live" shells and a couple of canteens, and the whole project was forgotten. Whatever else may have been there remains buried under Rock City today.

The great buried treasure hunt was barely over when Rock City announced its newest addition: a deer park. Carter ordered a herd of the unusual white fallow deer from breeder C.E. Thomas, who raised the dainty animals at his home near Prattville, Alabama. Thomas was quoted as saying, "I've placed my deer in many places all over the country, but I've never seen them go in a more beautiful place. This is by far the most attractive and appropriate place I have ever seen for these graceful animals."

The heady year climaxed with the installation of two new $1,185 binoculars at Lover's Leap, "the better to see seven states with, my dear," as Carter himself put it. It had been an amazing decade for the Carters and Rock City both, but if they thought they had already seen everything, they would have quite an awakening in the ten years to come.

*Chapter 3*

# GUIDES NOT NECESSARY;
# GNOMES OPTIONAL

With the advantage of hindsight, it is fascinating to look back over the decade that began in 1940. In the following ten years, enormous changes were to take place. In fact, the world of 1940 and the world of 1949 were so different that they almost seem like two separate planets. However, at the beginning of the decade, while a few individuals were keeping one eye on the clouds of war that were gathering in Europe, the tourist industry in Chattanooga was more concerned about a war closer to home: the Chattanooga Guide Association was again drawing battle lines, and this time things threatened to get even uglier.

The latest trouble stemmed from the fact that the Chattanooga Chamber of Commerce had decided to talk out of both sides of its mouth in a vain attempt to please everyone. When it appeared that Garnet Carter and his camp were going to win the earlier battle, Shirmer Brown and Ruby Falls had abruptly switched allegiance and had joined Rock City's side of the argument. The combined persuasive power of the two tourism titans convinced the chamber of commerce to erect billboards spelling out in large letters "VISIT LOOKOUT MOUNTAIN: GUIDES NOT NECESSARY," with the chamber's logo of approval. This action somewhat stuck in the guides' craw, since they had been going through miles of red tape deemed necessary to be licensed by the chamber of commerce. The new billboards spurred them into action once again, and soon, alongside the "NOT NECESSARY" signs, guide booths appeared painted with the slogan "THIS STATION AND GUIDES APPROVED BY CHAMBER OF

COMMERCE." The chamber could hardly deny the truth of this because, after all, it *was* licensing the guides. Still, Carter and Brown had put up a mighty good argument (not to mention a healthy share of the cost) for the new GUIDES NOT NECESSARY billboards.

On Friday, August 2, 1940, employees of both Rock City and Ruby Falls arrived to find picket lines in front of the two attractions. Carter and Brown were understandably indignant, and a formal hearing on the case was scheduled. Naturally, Rock City and Ruby Falls wanted the pickets removed from their property, but the guides seemed to be entrenched. Chancellor J. Lon Foust made a temporary concession by allowing the guide association to keep one picket in front of each attraction. It was also noted that the Rock City/Ruby Falls/Chamber of Commerce billboards had been defaced, with the

Rip Van Winkle, another of the figures imported to Rock City from Fairyland, seems to be totally bewildered by the antics of the Lookout Mountain guides after awakening from his long sleep. *Rock City collection.*

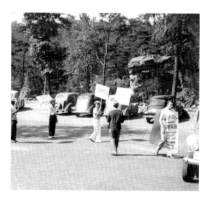

The Lookout Mountain guides picketed at Rock City's entrance in protest of their perceived ill treatment, with the now-departed Anvil Rock as a backdrop. *Rock City collection.*

word "NOT" in "NOT NECESSARY" smeared over by paint or a similar substance. This battle would rage on, but with the peak tourist season of 1940 rapidly winding down, the fight was put on hold.

Rock City lost no time in promoting itself when the spring of 1941 arrived. Full-page newspaper ads were taken out, with some amazing offers. For the regular admission price of one dollar, a visitor who presented the newspaper coupon could receive, at no extra charge:

(1) a souvenir felt pennant;
(2) a fan, printed with the familiar black-and-white SEE ROCK CITY ATOP LOOKOUT MOUNTAIN slogan;
(3) a smaller pennant badge to wear on the lapel;
(4) a 1941 desk calendar showing the famous view of seven states;
(5) a metal key chain emblazoned with Lover's Leap;
(6) ten of the full-color Curt Teich Rock City postcards; and
(7) a *free* look at the seven states through the "powerful binoculars" at Lover's Leap.

Yes, it was indeed tourist season again, and that was the cue for the next act in the continuing drama of the Lookout Mountain Guides v. Everyone Else. Once again, the guides began yelling for the chamber of commerce to find a solution to their precarious position. The chamber, torn between the two sides of the argument, proposed a "peace conference" to be held in April.

Like most peace conferences, this one produced a lot of talking but no lasting solutions. By late May, disgruntled tourists were again writing letters of complaint to the chamber, reporting the ill treatment they had received at the hands of the guides. The chamber found the matter complicated by the fact that, while its own licensed guides did indeed have a certain code by which to operate, there were still a large number of "independent" (i.e., unlicensed) guides who continued to frighten unsuspecting tourists into believing that their services were necessary in order to survive a trip to Lookout Mountain with life and limb intact.

Rock City then threw another couple of gasoline-soaked logs on the fire, thanks to Garnet Carter's latest advertising scheme. In

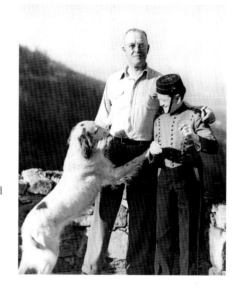

Among the celebrities welcomed to Rock City by Garnet Carter during the 1940s was "Johnny," the bellhop mascot of "Call for Philip Morrrr-isssss" cigarette radio commercials fame. *Rock City collection.*

those days, very few highways had stripes painted down the middle, and there was certainly no established format for the lines as there is today. Therefore, Carter painted a yellow line on Highway 58, leading from the bottom of the mountain directly to the front gate of Rock City. (At the same time, a white line was painted leading to Point Park.) Then, a new advertising slogan was added to the ranks of "SEE ROCK CITY" and "SEE SEVEN STATES": literature and signs announced "FOLLOW THE YELLOW LINE TO ROCK CITY."

This information was distributed to motels, restaurants, tourist courts and other locations where it could easily be placed into the hands of travelers. The FOLLOW THE YELLOW LINE slogan was sometimes augmented by such phrases as "DRIVE YOUR OWN CAR TO ROCK CITY" and "NO GUIDES NECESSARY." This was a direct kick in the pants to the guides, who responded by once again establishing a picket line in front of Rock City's entrance building. This time, the picket line had more backing than similar efforts of the past, as the Chattanooga Guide Association was now affiliated with a union, the Council of Industrial Organization.

Garnet Carter responded to this latest siege of his Gardens as follows:

> *We've had demands from the guides which are impossible to meet. They seem to think it's okay for them to flag down cars and tell the tourists anything they want to, but it's a horse of a different color if we distribute maps showing how to get to Rock City without employing guides.*

Activities during this round of picketing began to turn nasty. There were reports of police mistreating and physically abusing the picketers, and the whole thing seemed to be heading for a major "Gunfight at the Rock City Corral," when Carter succeeded in getting a temporary injunction against the picketers. By September, picketing at Rock City had been suspended until another hearing on the case could be held. Before the next tourist season could arrive, though, there was another event that rendered the whole argument moot.

It was just as well that there came a hiatus in the Rock City/Guide Association war because, as of December 7, 1941, the nation had a much more important war about which to worry. The United States was plunged into the middle of the boiling world conflict, and suddenly everyone's lifestyles were altered forever.

The American public came to know about such things as rationing, which made items formerly taken for granted almost impossible to obtain. Gasoline and rubber tires were among the first rationed items, and this had an immediate effect on tourist attractions. All of a sudden, people were unable to travel as they once had, and Rock City simply gritted its pebbles and dug in for the duration. Ironically, Chattanooga tourism was the subject of one of the biggest hit songs of the war years, Glenn Miller's recording of "Chattanooga Choo-Choo." Americans went around humming the swing tune (in which Rock City was not mentioned), but few of them could manage to do the type of unnecessary traveling the song was celebrating.

Wartime conditions also put a temporary halt to the painting of any new Rock City barn roofs. Clark Byers served a brief stint in the military, and during that period no new rooftop ads were produced. It didn't really matter too much at the time, since there were very few travelers on the highways anyway. The business of

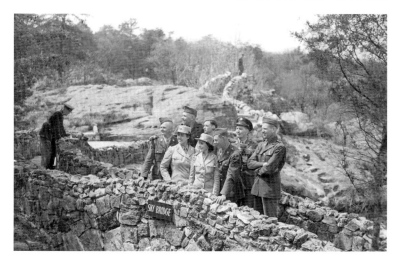

During World War II, when gasoline and tire rationing kept tourists at home, Rock City managed to survive by catering to soldiers and WAACs stationed at nearby Fort Oglethorpe. *Rock City collection.*

war surplus supplies later provided Byers with huge amounts of black paint at a ridiculously low cost, so the conflict was at least going to do some good for the barn roofs in the future, even while it was causing a momentary setback.

During the war, Carter and Rock City depended heavily upon nearby army camps, especially Georgia's Fort Oglethorpe, as a source of visitors. A great many members of the WAAC (Women's Auxiliary Army Corps) were stationed at Oglethorpe, and Carter used his considerable influence to obtain soft drinks and other such ration-ravaged items for them when they visited his Gardens. A writer for the *Columbus* (Ohio) *Dispatch*, I.C. Brenner, made a wartime visit to Rock City and turned in the following report:

> *In peacetime tourists from Maine to California and from a good many foreign countries used to spend an hour and a half climbing among the moss-hung rocks and over the rustic bridges to see the views and the rocks. The view takes in portions of seven states.*
> *Carter and I sat in his office and looked out the 10-by-10-foot picture window overlooking the wildflower bordered rocky*

*trails. Carter pushed his cap to the back of his head and said, "Oh, I'd say we used to get about 500 to 600 tourists every Sunday. Rationing has hurt us some, but they come up on the Incline and bus." He shifted in his chair, swiveled around to face the window and chuckled. "You know, I enjoy just sitting here and watching this all day long. All these people come here and walk around for an hour or so, wear themselves out, and pay me for the privilege of doing it! No upkeep, except the flowers and bridges and things like that. The rocks stay there; they don't need water, cleaning, or painting; they never wear out, and they never die."*

Not a whole lot of activity was going on around Rock City between 1942 and 1945, but once the war began winding down, things started to inch back toward their normal fever pitch. An unusual story appeared in the newspapers in April 1945. It seems that nine-year-old Renee McRee had to be quarantined with scarlet fever, and her grandmother determined to cheer the little girl up by writing a story for her. The newspaper reported what happened next:

*Since Mrs. McRee's older son, Maj. Joe McRee, Renee's father, is fighting in Germany, and since Renee had developed an unusual interest in Lookout Mountain's internationally famous Rock City Gardens, Mrs. McRee took bits of the war, placed them and Renee in the Rock City setting, and fashioned a "real live" fairy tale.*

*Although the book, 22 pages long and illustrated with magazine clippings of the war and fairy story characters, was written for only one little girl, Garnet Carter, owner of Rock City Gardens, recognized the work immediately as one that would appeal to all little girls, boys, and even adults.*

*So Mr. Carter arranged to purchase publishing rights and began laying plans for general distribution as souvenirs and as publicity for the gardens. He expressed belief that many thousands of copies of the unusual book can be sold, particularly after the war when as many visitors from all parts of the world visit the*

*gardens as formerly. The book features Renee and Mrs. McRee in Fairyland's Rock City, a story of a live little girl roaming the picturesque mountainside of unique rock formations with dwarves and fairies brought to life. The title is "Renee and the Fairies in Rock City."*

*Carter said his primary difficulty now is finding facilities for large-scale publication. He said he may have to be content at present with black-and-white reproduction until after the war.*

It is not known whether this children's book was ever actually marketed by Rock City, but even if it had been sold to tourists it would have been quickly buried in the frantic activity that commenced just as soon as peace was declared. It was as if all of Rock City's normal enthusiasm had been bottled up during the war, and once things got back to normal it exploded in a breathtaking manner. A large dose of it was unleashed onto the public in a single press release on March 22, 1946.

The release announced that the Federal Communications Commission (FCC) had given a tentative grant for an FM radio station, with the 640-foot transmission tower to be placed in Rock City. Construction was to begin as soon as the tentative grant was changed to a permanent one by the FCC, and Garnet Carter took the opportunity to announce five major changes that were coming to Rock City, plus a few small ones:

*1. Construction of a 200-foot observation tower and platform near the east bluff of the mountain within Rock City. This tower, complete with elevators, will be constructed of stone to blend with Rock City's "atmosphere" and will serve as a base for the radio transmission tower, which will rise 440 feet above the observation platform.*

*2. Construction of a narrow gauge railway which will carry visitors to Rock City the last 200 yards of their trip through the unique development. The gasoline engine locomotive and passenger cars already have been ordered, Mr. Carter said today, and work is already well under way on the road bed, part of which is being blasted through solid rock.*

*3. Installation of a 110-foot artificial waterfall from Lover's Leap, famous historic and scenic spot within Rock City. The falls will be kept in operation by means of a 1000 gallon pump, which Mr. Carter purchased today from J.B. Holliday of Atlanta, representative of Gould Pumps, Inc., of Seneca Falls, New York. Mr. Holliday said the pump is the "largest and most efficient" manufactured by his company.*

*4. Already under construction is a new coffee shoppe to the right of the main Rock City lobby and office building. The present coffee shoppe will be converted to an additional lounge and writing room.*

*5. Also already under construction is a new souvenir shop to the left of the main building, clearing the main lobby and permitting accommodation of a greater number of persons. Mr. Carter said today he also plans to build another wing on the main building to house his own offices.*

*The court in front of the main building, previously used as a parking area, will be covered with crab orchard stone and fountains and other adornments constructed to beautify the entrance. The Rock City owner is also constructing two new parking areas to take care of automobiles, which are arriving in increasing numbers from all parts of the country.*

Many of these plans were eventually brought to fruition, while some others were not. The radio station and its accompanying lookout tower in the Gardens were never built, although Rock City would later, during the 1960s, become involved in the ownership of a Lookout Mountain radio station. The "narrow gauge railway" was also aborted; what little of it had been completed was used mainly as a photo opportunity near the end of the trail. The new "coffee shoppe" and souvenir shop, as well as the improvements on the entrance court, were finished without a hitch and became permanent fixtures of Rock City.

Out of all of these plans, the creation of High Falls at Lover's Leap probably made the most lasting impact. People had trouble realizing that the falls were man-made, and many probably do not realize that fact even today. There were amusing stories of

High Falls, at Lover's Leap, was one of the first sights added to Rock City after the end of World War II. Even though Rock City did not keep it a secret that the falls were man-made, many people do not realize that fact even today. *Rock City collection.*

couples who, while having dinner at the nearby Fairyland Club and enjoying their view of Lover's Leap, would be tempted to give up cocktails when suddenly the magnificent waterfall would shut off at sundown!

Even with all the new plans and activities, Garnet Carter was troubled. He was now in his sixties, and he realized that he would not be around forever to ensure that Rock City would continue to grow and prosper as it always had. He was also terribly concerned that Frieda—who by now was blind and an invalid—might outlive him, and he desperately wished that she might die first and not be left alone. Since the Carters had no children, Garnet found himself facing a possible crisis.

In a letter to his sister, Carter explained:

> *To tell you the truth, I figured that Rock City would be a good old man's job, but we keep on improving it and advertising more and more, so consequently the patronage continues to increase. And instead of it being an old man's job, I felt I needed help to carry on.*

Carter searched within his own family and found a likely candidate to be his successor: Edward Y. Chapin III, the son

of Carter's sister Doris. (Chapin's father, E.Y. Jr., had been one of the businessmen who was associated with Carter in the ill-fated Mystery Falls project of 1938.) The Chapins were a well-established banking family in Chattanooga, and Carter saw that as the only possible drawback to his plan:

> *It never occurred to me that E.Y. III would even be interested. In fact, I knew he would go in with the bank, as his destiny had already been planned, and of course he had a wonderful opportunity there, but he didn't wish to follow up on it. He went into the insurance business instead and has done awfully well. In fact, he is a salesman; in other words, probably more of a Carter than a Chapin, or Rock City would not have appealed to him.*

Chapin came aboard in January 1948. Some of his first activities at Rock City were performed to make the attraction operate on a more professional, businesslike basis, as opposed to the one-man operational style of the past. Chapin explained what things were like during that period:

> *Uncle Garnet was of the old school, like that it is better to have a lot of business and no books than a lot of books and little business. So he just put the emphasis on business rather than on books. He had meticulous records for those things he wanted to keep records of, but there were just some things he didn't care about recording. He recognized that for Rock City to continue it had to have some direction that no one around him at the time was able to supply. One man can run a business of a certain size all right as long as he is there, and as long as he understands what is going on. But you have to have some system. Also, it was in that period the government was getting more involved and there were many new laws that had not been out when he was getting started.*
>
> *One day we got a visit from the Internal Revenue Service. They wanted to know what controls we had and why we didn't have any tickets. Uncle Garnet said, "Well, we just don't need*

The narrow-gauge railway that was supposed to carry visitors through the last two hundred yards of the Rock City trail was never completed and instead became merely a photo opportunity. *Rock City collection.*

*any tickets. The government has been good to me and I'm good to the government. Everybody that comes up here, I just take the money and see that we divide it up."*

*The Internal Revenue man said he didn't think that was the right way to do it, and said he would like to have us put in a turnstile. Uncle Garnet said, "Why, if we didn't want to be honest with you, we'd just run them around the turnstile, and then where would you be?" The man then said he would send someone up to watch. Uncle Garnet said, "Well, I'd just keep him drunk." We had done everything properly, but Uncle Garnet just had a different way of looking at it. They let us change over during the off season.*

*The closest we ever came to a fight was when we were going to put in the tickets. He thought the idea of tickets was absolutely ridiculous and I felt we had to have some controls. He said something about it and I told him it sounded cockeyed to me, which it did. But he thought I'd said he was cockeyed, and he stormed off in high dudgeon, mumbling about how it was his business and he would do things the way he wanted. I let him stay over at his house a few minutes and then went over and*

*explained I had not intended to say that he was cockeyed at all,
but that I did think his idea was wrong and I had to express
myself. In the meantime he had thought about it and realized
that he was overstating the case, and he agreed to go along with
what I had proposed.*

As a result of Chapin's business experience, in March 1948 the
attraction was incorporated as Rock City Gardens, Inc. This helped
the company keep track of all of its various assets (the Gardens,
the real estate division still known as the Fairyland Company and
so forth). Garnet Carter was appointed the first president of Rock
City Gardens, Inc., with Ed Chapin as vice-president.

Besides changing around business operations, Chapin found
himself involved in an even larger-scale development of Rock
City. This time, activities were underway to give the attraction
a greater appeal to the children who were accompanying their
parents. This was part of a trend everywhere—once the soldiers
returned from their overseas wartime duties, they wasted no time
at all getting married and producing progeny at a prodigious rate.
This procreation was the start of the so-called baby boom, which
dramatically increased the number of children to be catered (and
appealed) to.

At about the same time, Garnet Carter was buying some hand-
carved souvenir items from an Atlanta artist, Charles Sanders.
Sanders noticed the many gnome figures that were so much a part
of Rock City's decor, and he mentioned that his wife Jessie was also
a talented sculptor. Might their studio be able to provide Carter
with any more elves, he wondered? Jessie Sanders recalled that
Carter groaned and replied that he had more of the German elves
than he could ever find a use for, but he did need some figures of
other types. His imported Snow White scene needed the figure of a
baby deer, and Mrs. Sanders agreed to take a stab at it, even though
she had never sculpted anything that large before. When Carter
saw the finished Bambi look-alike, he was ecstatic and immediately
began making big plans for the artistic Sanders couple. It is difficult
to know just how inspiration would strike, but somehow Carter
conceived the idea of an entire series of fairy tale scenes, to be

placed in a man-made cave he would call Fairyland Caverns (the culmination, perhaps, of all the development that had gone into the Fairyland community and Tom Thumb Golf in the past).

Before construction began, the part of Rock City that is now Fairyland Caverns resembled a longer, wider version of Fat Man's Squeeze. The first attempted development of the site had been some drilling and blasting for the ill-fated narrow-gauge railway. Carter and Chapin now widened this existing crevice and put a roof over it. The ornate metal sign that had once adorned the entrance to the Fairyland neighborhood was placed over the doorway. But it was the inside of this created cave that was the most innovative.

No one really knows how Carter arrived at the idea to illuminate his Fairyland Caverns scenes with ultraviolet light, popularly known as "black light." It had been used in law enforcement, the military and for medical purposes since the 1920s, but its potential value in

 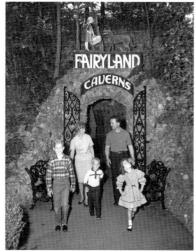

*Above left*: This baby deer was the first figure sculpted for Rock City by Atlanta artist Jessie Sanders. It can still be seen as a part of the Snow White diorama. *Author's collection*.

*Above right*: Fairyland Caverns was Rock City's way of responding to the postwar baby boom that would effectively change the face of the tourism industry between 1946 and 1964. *Rock City collection*.

the entertainment field was almost unrealized. Carter may or may not have seen black light used in amusement park fun houses (which came to be known as "dark rides"), but he somehow knew that he wanted it to be a major part of his beloved Fairyland Caverns.

The work on Fairyland Caverns was a continuing process. Its construction made a major change in the final section of Rock City's Enchanted Trail. One of the sights that had to be omitted by the rerouting of the trail was the Stone Witch, which had been a part of Rock City's publicity from the very beginning. The part of the trail containing the Stone Witch was sealed off to future tourists, although the petrified, hook-nosed necromancer still exists in a wooded area that is no longer easily accessible to the average visitor.

At first, Fairyland Caverns featured only the few storybook characters that had been imported previously. Little Red Riding

*Above left*: When construction of Fairyland Caverns caused the rerouting of the end of the Enchanted Trail, the Stone Witch became one of the sights that were no longer visible. *Rock City collection*.

*Above right*: When not seen under black light, the stalactites and other "formations" in Fairyland Caverns betrayed their man-made origins. This seemed to bother no one, especially the children, who found the "caverns" totally enchanting. *Rock City collection*.

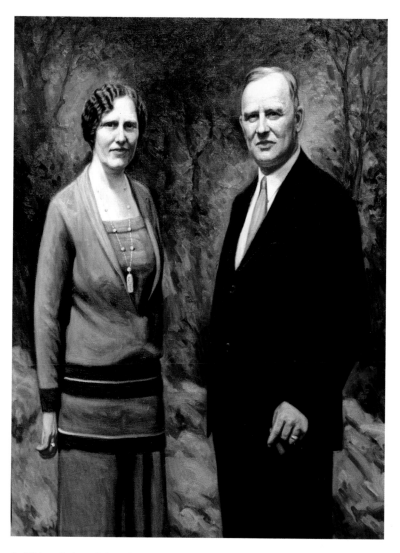

1. This painting of founders Garnet and Frieda Carter has hung in the Rock City administration office for at least fifty years. *Rock City collection.*

2. The story of Rock City truly begins with the Fairyland neighborhood and its accompanying luxury hotel, the Fairyland Inn. *Rock City collection.*

3. When Rock City Gardens opened to the public in May 1932, no one could have predicted what a legend of roadside tourism it would become. This is one of the early souvenir booklets, dating to 1938. *Author's collection.*

4. In the days before highway markings were standardized, Rock City painted a yellow line in the middle of the highway leading from the base of Lookout Mountain to the attraction's front gate. *Rock City collection.*

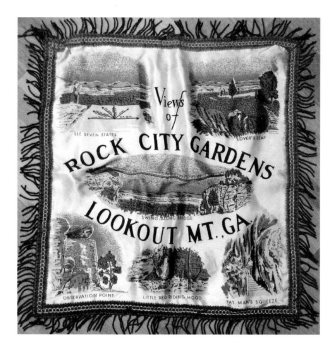

5. Souvenirs were always a big part of any visit to Rock City. This pillow cover was only one of the hundreds of different items available in the 1930s and 1940s. *Author's collection.*

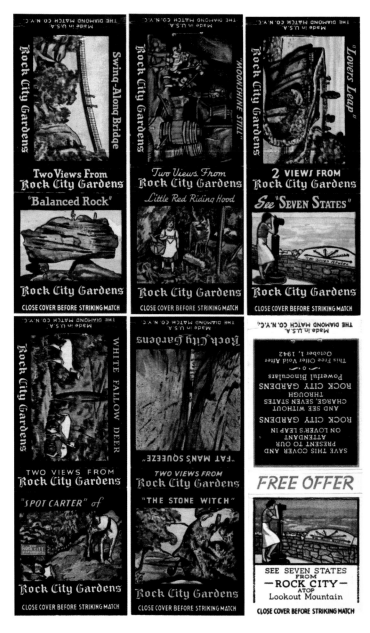

6. Some of Rock City's most unusual promotional items were these souvenir matchbooks. Notice that one of them features a special offer for a free look through the binoculars at Lover's Leap—an offer that expired in 1942. *Author's collection.*

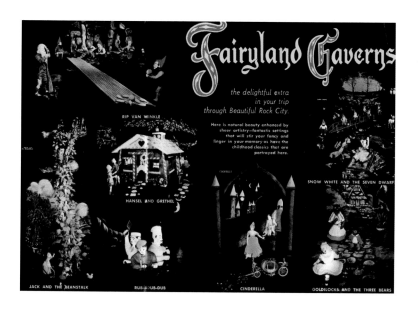

*Above*: 7. Rock City's biggest addition of the post–World War II era was Fairyland Caverns, a series of tableaux sculpted by Jessie Sanders and illuminated with black light. *Author's collection.*

*Right*: 8. The Fairyland neighborhood, and subsequently Rock City, was known for its many statues of gnomes imported from Germany. When Fairyland Caverns was constructed, most of the gnomes were moved "indoors" to ensure their future preservation. *Rock City collection.*

*Left*: 9. The original figure of Little Red Riding Hood that was purchased for the Fairyland neighborhood in 1925 is still the centerpiece of her namesake scene in Fairyland Caverns today. *Author's collection.*

*Below*: 10. Not all of the Fairyland Caverns scenes survived beyond the early years. This rather primitive "end of the rainbow" scene was one of the casualties, although the rainbow motif would resurface in Rock City's advertising during the 1970s. *Author's collection.*

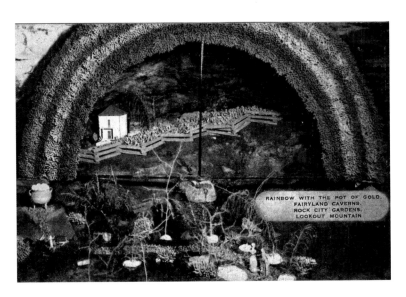

RAINBOW WITH THE POT OF GOLD.
FAIRYLAND CAVERNS,
ROCK CITY GARDENS,
LOOKOUT MOUNTAIN

*Right*: 11. This was one of the few scenes for which Jessie Sanders provided a minimal amount of animation, as the "tub" rocked back and forth in its nighttime voyage. *Rock City collection*.

*Below*: 12. Framed prints of this color photograph of Lover's Leap were supplied to motel owners and hung in motel rooms throughout the Southeast during the 1950s and 1960s. *Rock City collection*.

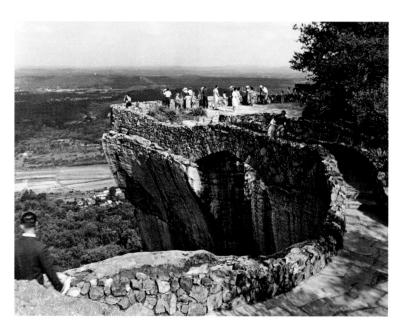

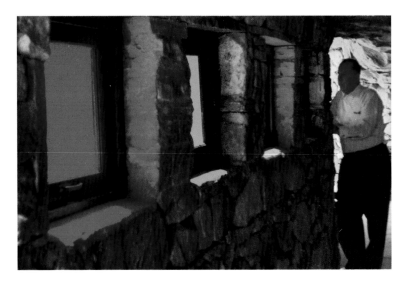

13. Rainbow Hall was an example of a Rock City feature that served no purpose except to be colorful. Visitors could view the valley below through alternating colored panes of glass. *Author's collection.*

14. Rocky the elf, who would become Rock City's most visible advertising symbol, underwent a slow evolution between the late 1940s and early 1960s. *Rock City collection.*

*Above*: 15. By the late 1950s, the red and black Rock City birdhouses had almost replaced the famous painted barn roofs as the attraction's most common roadside advertising. *Rock City collection*.

*Right*: 16. When the Russians launched their Sputnik satellite in 1957 and started the space race, it is somewhat surprising that Rock City's Christmas card did not bear the slogan "See 48 States." *Rock City collection*.

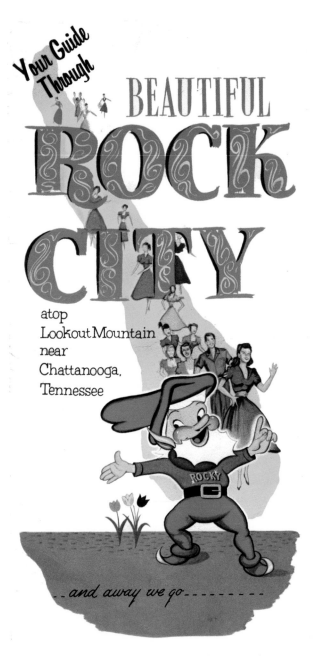

17. By the early 1960s, Rocky was appearing everywhere, including on the cover of this eye-poppingly colorful guide booklet. *Rock City collection.*

18. Chattanooga in general, and Lookout Mountain in particular, drew much of its tourism business from travelers heading to or from the Great Smoky Mountains. *Rock City collection.*

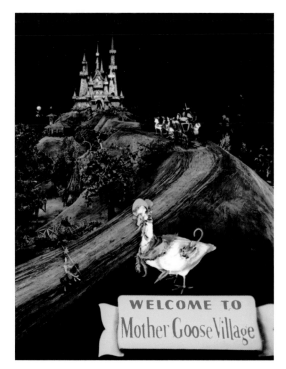

19. After six years of work, in 1964 Rock City unveiled Jessie Sanders's Mother Goose Village, a single huge diorama under black light. *Author's collection.*

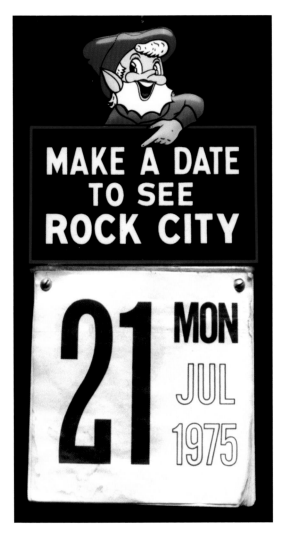

*Above*: 20. Most of Rock City's souvenirs emphasized sights such as Lover's Leap or the Swing-A-Long Bridge, but this pennant instead depicted several of Jessie Sanders's fairy tale characters. *Author's collection.*

*Left*: 21. These metal calendar holders were distributed to motels, restaurants and gas stations in the early 1960s. As you can see, time stood still for this one on July 21, 1975. One wonders what happened to its home business after that date. *Author's collection.*

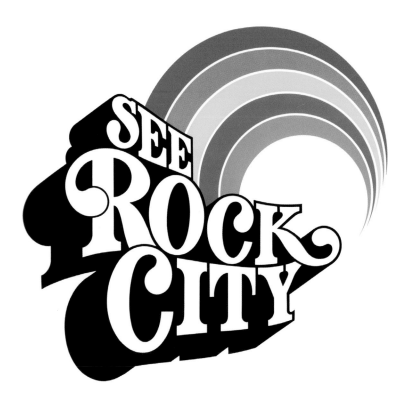

*Above*: 22. In 1977, Rock City unveiled this new "rainbow logo" that was definitely a product of its own time. It was the first modification of the traditional white letters against a black background that had been used since the 1930s. *Rock City collection*.

*Right*: 23. Rock City took pride in the fact that it was beautiful at any time of the year. Here, the statue memorializing Garnet Carter's beloved dog Spot overlooks the Grand Corridor after a light snowfall. *Rock City collection*.

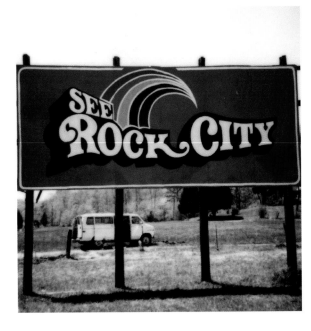

24. In the mid-1980s, Rock City decided that its black billboards were no longer presenting the proper image, and sign painters Tommy and Lynn Moses set out on a journey to repaint all the backgrounds a brilliant sky blue. *Rock City collection.*

25. Ninety-one-year-old Jessie Sanders, by then a resident of the Life Care Center nursing home, paid one final visit to Rock City and got cozy with Rocky in 1991. *Rock City collection.*

26. Christmas displays had been part of Rock City since the early 1970s, but the annual Enchanted Garden of Lights became a spectacular new tradition after its 1995 debut. *Author's collection.*

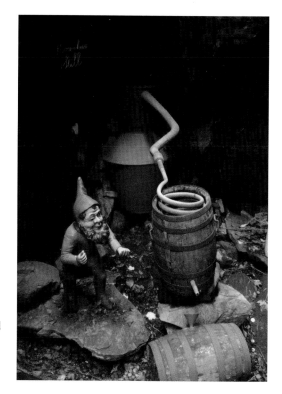

27. The Moonshine Still diorama has brewed its mountain dew since 1933. Age and wear have reduced its once-large cast to only a few remaining gnomes. *Author's collection.*

*Left*: 28. The original Carnival of the Gnomes scene in Fairyland Caverns still presents a spectacular sight with its spinning Ferris wheel and colorful inhabitants. *Author's collection.*

*Below*: 29. Today, visitors to Rock City are greeted by a costumed version of Rocky as they approach the entrance building that was constructed in 1937. *Rock City collection.*

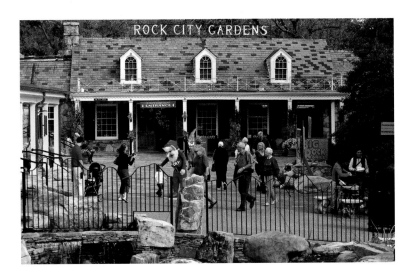

As seen here, the earliest Fairyland Caverns scenes appeared a bit claustrophobic. Red Riding Hood, the wolf, Rip Van Winkle and the bowling gnomes all took up permanent residence in the caverns after serving well in the Fairyland neighborhood and along the Enchanted Trail. *Rock City collection*.

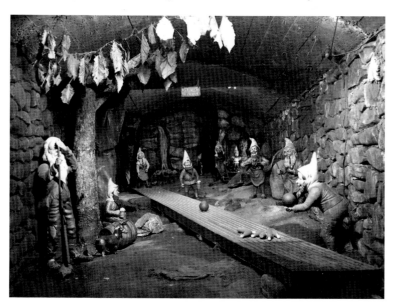

In order to fill space, the metal signs and geese statues from Frieda Carter's Mother Goose Village were painted in fluorescent colors and placed in the new Fairyland Caverns. *Rock City collection.*

Hood and the wolf were moved in from their exterior display area, as were Rip Van Winkle and his bowling gnomes. Snow White and the Seven Dwarfs (plus Jessie Sanders's deer) also found a new home in the Caverns, as did some of the identifying signage from Frieda Carter's Mother Goose Village houses in Fairyland. Most of the elves that had formerly been stationed throughout the Gardens were moved into the first couple of rooms in Fairyland Caverns, and their bailiwick was named the Castle of the Gnomes.

Jessie Sanders said that she was given free rein to create the scenes she wanted as inspiration struck. Carter and Chapin did specifically request that the opening scene depict a mother reading bedtime stories to her two children, and that the second diorama show the children asleep in bed as their "dream fairies" floated through the window. Mr. and Mrs. Sanders were able to elaborate on these basic instructions and created scenes that were more beautiful than anyone could have imagined. Jessie recalled that even Frieda Carter expressed her appreciation for the new figures. Although Mrs. Carter could no longer see, she ran her hands over the statues and her own innate artistic sense filled in the blanks.

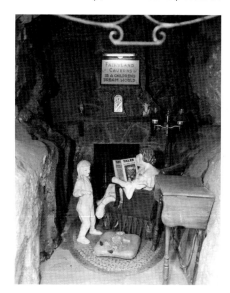

When Charles and Jessie Sanders began sculpting the figures for Fairyland Caverns, Garnet Carter requested that the first scene depict a mother reading bedtime stories to her children. *Rock City collection.*

Jessie claimed that the biggest aspects of Fairyland Caverns she had to learn about were the special problems presented by working with black light. The fluorescent paints had to be specially mixed in order to give the proper hue of color, and the directional black lights themselves had to be positioned in very particular ways or the effect would be lost. She received a lot of help in the technical side of things from Don Gault, one of the workers who had been with Rock City literally from the beginning.

When the husband-and-wife Sanders team first began producing the Fairyland Caverns scenes, they continued to maintain their studio in Atlanta. The completed figures would be shipped to Rock City, where another artist, Marcus Lilly, was at work painting the backdrops for the scenes. Finally, Mr. and Mrs. Sanders closed their Atlanta location and moved lock, stock and fluorescent paint cans to Lookout Mountain, where they set up operations in a Rock City studio created for just that purpose. Mrs. Sanders began to handle the painting of many of the backdrops herself. One of her earliest was the Carnival of the Gnomes, which nearly drove her up the rock wall because the backdrop was on a curved surface instead of a flat one, creating special problems with perspective. The scene

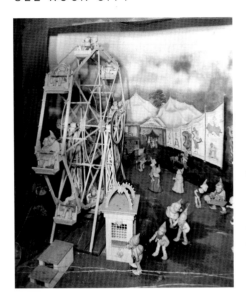

This early view of the Carnival of the Gnomes scene shows that, initially, good, old-fashioned barbed wire was used to keep potential troublemakers from disturbing the carefully crafted dioramas. *Rock City collection.*

also required the figures of women and children gnomes, and these perplexed Mrs. Sanders because the only gnomes she could find illustrated in books were depicted as bewhiskered little old men. She finally solved the problem by making the women and children look like miniature humans with pointed ears.

Jessie Sanders never used a sketchpad to plan her figures ahead of time, preferring to work straight from her own imagination. She did research for each scene, thumbing through old illustrated books of fairy tales for inspiration. She studied the ragamuffin appearance of late 1940s war orphans to get the pathos necessary for Hansel and Gretel, and a drawing in a coloring book inspired the "witchy tree" that loomed behind the two children. When sculpting the figure of Cinderella fleeing from the ball at midnight, Mrs. Sanders posed in front of a mirror in order to get the position of the hands just the way she wanted. She designed new settings for the Red Riding Hood, Rip Van Winkle and Snow White scenes that had been moved in from the outside, but sculpted an entirely new figure of Snow White herself, as the original German statue looked a bit stiff and unnatural compared to the newer scenes. (As the new Snow White was shown being awakened by a kiss from the prince,

At first, the new Snow White setup featured the same standing figure that had been imported in 1938 (left), but soon Jessie Sanders sculpted a more realistic reclining Snow White (right), with the prince awakening her from her magic sleep. Notice that the 1925 Fairyland figures of Mr. and Mrs. Br'er Rabbit ended up as residents of this scene. *Rock City collection.*

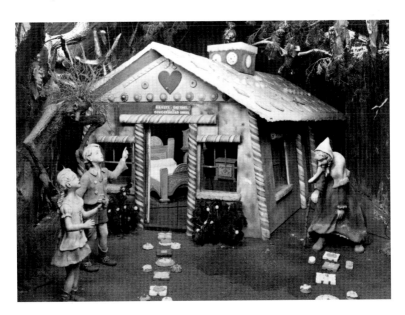

Jessie Sanders was always particularly proud of her Hansel and Gretel scene, especially the "witchy tree" that loomed over the two ragamuffin children. *Rock City collection.*

at times this scene has been mislabeled as Sleeping Beauty—from which story Walt Disney had lifted the "love's first kiss" shtick in the first place.)

Generally, Charles Sanders would carve the props for each scene, while Jessie handled the characters. Mrs. Sanders would first create a full-size clay model of each figure, which would be used to fashion a mold. The final figures would then be cast in Hydrocal, a gypsum cement substance that was harder than plaster or ceramics. She would then coat the figures with the fluorescent paints. They would have to be repainted often because of the dirt and grime that would accumulate in the man-made tunnel.

Since Fairyland Caverns was not completed all at once, its actual opening date is a matter of opinion. Work on it began in earnest in 1947. Newspaper articles in August 1948 mentioned the Caverns as Rock City's newest attraction, but over a year later, in October 1949, other articles were referring to it as having just been completed. The artistic Sanders couple would continue to add to and improve Fairyland Caverns as the years went by. An obscure fact is that a couple of years after they began their project, Jessie became quite put out with Garnet Carter's sometimes aggravating inability to express to her what he wanted and his subsequent criticism of what she had actually produced. At one point, she became so frustrated that the Sanderses packed up their supplies and moved back to Atlanta. Finally, Carter managed to persuade them to return, under the condition that he would not interfere with their artistic visions again. They all became fast friends from that time on, and Mr. and Mrs. Sanders remained on the job at Rock City for many more years.

By now, the FOLLOW THE YELLOW LINE slogan that had begun in 1941 as part of the guide war had become almost as well known as Rock City's other trademark phrases and had even been set to music. A song entitled "Rock City" was recorded by a quartet of members of Chattanooga's Kiwanis Club, backed up by the Dismembered Tennesseans (an entertainment group composed of Chattanooga businessmen). The lyrics, which poked good-natured fun at the seemingly omnipresent Rock City roadside advertisements, had originally been written by Dorothy Hedges for a Junior League Follies show and went like this:

In this rare candid shot of Jessie Sanders from the late 1950s, the artist is seen with a container of Hydrocal®, the material in which her Fairyland Caverns creations were cast. *Rock City collection*.

Some of the early Fairyland Caverns scenes did not survive once new ones were built to take their place. This nighttime shot of a miniature village, complete with a Rock City barn in the foreground, was one of the casualties. *Rock City collection*.

*Every opening chorus should be vocal,*
*But we're determined ours should all be local;*
*So here we are, as tourists come to see,*
*Two thousand miles we've traveled, to buy publicity.*
*On every road and highway that we see,*
*The signs on fences, barns, and every tree:*
*"The World's Eighth Wonder" we're about to see,*
*And all we have to do is*

71

*Follow the yellow line up Lookout Mountain to see Rock City;*
*Travelers and tourists come from every land,*
*There the slogan ought to be "Ain't Nature Grand?"*
*Follow the yellow line to see this wonderful spot...*
*You've heard about the serpent who told Eve that she was*
*pretty,*
*And, handing her the apple, said, "Okay now, kid, get busy!"*
*The sign upon that apple tree said VISIT ROCK CITY.*
*Rock City, that garden city,*
*Rock City, GA!*

*Follow the yellow line up Lookout Mountain to see Rock City;*
*You will meet aristocrats and hoi polloi,*
*Everyone concerned comes out a Nature Boy!*
*Follow the yellow line to see this wonderful spot...*
*The colonies were settled by a little Pilgrim flock,*
*Who came across the waters, landing right on Plymouth Rock.*
*The sign they saw emblazoned there gave them an awful shock:*
*it said*
*ROCK CITY, that garden city,*
*Rock City, GA!*

*Follow the yellow line up Lookout Mountain to see Rock City;*
*If your sweetheart won't respond to all your pleas,*
*You can always steal a kiss in Fat Man's Squeeze.*
*Follow the yellow line to see this wonderful spot...*
*They say you can see many states, well maybe ten or 'leven;*
*We don't think they exaggerate when they mention only seven.*
*It's only fifteen hundred million light years from heaven.*
*Rock City, that garden city,*
*Rock City, GA!*

But changes were looming on the horizon as the tumultuous decade staggered to a close. Despite the popularity of the yellow line in song and advertising, its days were definitely numbered. Ed Chapin remembered what happened:

The relative size of Jessie Sanders's sculptures to human beings is demonstrated in this unusual view of E.Y. Chapin and some young friends visiting Cinderella. *Rock City collection.*

*We received a letter from the Highway Department, saying it was illegal to advertise in the middle of the highway. At that time, the yellow line as a passing warning was nonexistent. We went over to Nashville to try to argue that the yellow line was necessary and that we should be allowed to keep it. It was soon apparent, however, that we were not going to do any good, so we went back to the hotel.*

*We were lying there on the beds, and Uncle Garnet said, "Let's have a drink." So we had a drink of Scotch and he said, "Ed, isn't there a number on that road going up Lookout Mountain?" I said it was Highway 58, but I wasn't really sure, and he wasn't sure at all. But he said, "I think we'll just tell everybody to come up Highway 58. I think that might be better than the yellow line anyway. That way all the traffic will come up the same way." So he sat there and had another drink, and after a while he said, "By golly, I'm going to go back and tell those fellows about that."*

*We went back and knocked on the door, and the guy in charge of the highway program saw us coming and looked like he was thinking, "Oh my gosh, what are those two drunks doing coming back to see me now? Haven't we already settled this thing?" We went in and Uncle Garnet stuck out his hand and said, "I want to thank you for giving us the best idea we ever had. We don't want that yellow line any more, but you have to promise me one thing. You have to keep that highway marked." They agreed to that, and we have advertised that way ever since.*

On June 7, 1949, a mountain resident who had seen the yellow line on his way to and from work for years called the newspaper in alarm. A white line had been painted over the yellow line! When contacted for an explanation, Rock City's story did not reveal quite all of the details that had led to the line's removal, but it gave a good enough reason of its own:

*E.Y. Chapin III, vice-president of Rock City, said they don't want to hold the line any more. Line...schmine...Chapin said in so many words this morning. Who needs the line?*

*"From now on," said the vice-president, "we are going to advertise 'follow Highway 58.' We think that will be a stronger slogan. We feel that State Highway 58 is an official marker and can be better followed than the line. It should be four times better. Rock City just outgrew the line. Highway 58 will now take its place. It will take tourists to the heart of town, to the middle of Chattanooga, and right up on top of the mountain. If signs keep telling 'em to follow Highway 58, then they won't even know the difference. Besides, give us about three days and you won't see a yellow line sign in the United States."*

It had been an amazing decade, and the one yet to come would see the true flowering of the tourism industry, bolstered by the sudden glut of new families. Rock City would find new challenges to meet, and as per the norm, it would come up with ways to turn them into new opportunities.

## Chapter 4

# GAS, FOOD, LODGING...AND BIRDHOUSES

By 1950, the effects of the baby boom were being felt in nearly all areas of life, but especially so in the travel and tourism industry. The children who had been born during the first wave in 1946 were now four years old and ready to accompany their parents on family vacations. The fathers, returned World War II soldiers, generally found the United States to be in an unprecedented period of postwar prosperity. Many of them had received their military pay in one lump sum and, combining this with their new civilian jobs, had more ready cash to spend than they had ever dreamed about before. The fact that they had recently been exposed to travel themselves made them more anxious than ever to take their new families and "see the USA in their Chevrolet," as a commercial of the day put it.

It was during this decade that roadside tourism really and truly became a major industry. Motels and tourist courts used ever bigger and flashier colorful neon signs that pulsated in the night, competing with one another for a visit from travelers. Mom and pop restaurants were seemingly located around every bend of the highway, each promising more mouthwatering home cooking than the last. William S. Stuckey first sold his pecans from a single Eastman, Georgia roadside stand during the 1930s. In 1941, he had a total of three locations, all of which had to be closed up during the war, but by the 1950s he was spreading his yellow-and-red signs across the nation. Similar to what Rock City had been doing all along, the Stuckey's billboards usually announced the distance to the next location.

The story of Rock City during the 1950s is primarily a tale of advertising and promotion. For the time being, it looked like the Gardens had made all the additions and improvements they could, so the concentration turned to ways of getting more and more tourists through the turnstile.

In 1950, Ed Chapin was officially made president of Rock City, allowing Garnet Carter time to slip into semiretirement. Carter continued to remain around his prized property, as he enjoyed sitting out front and talking with the customers anonymously. He also proved that his legendary "negative selling" powers were as sharp as ever. Once, Carter was dressed in his golf clothes and a lady visitor assumed he was simply another tourist. Looking at the photographs displayed at the entrance, she asked Carter if he thought it was worth a dollar to see Rock City. He replied, "Well, ma'am, I wouldn't pay it, but everybody does." She paid the admission and went in.

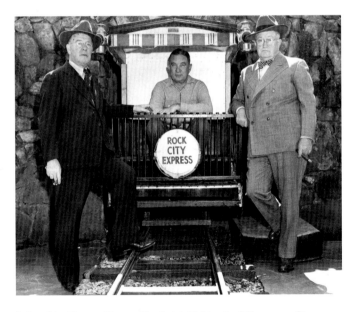

*Left to right*: Garnet Carter, Hardwick Caldwell of Tennessee Stove Works and Peyton Carter pose with the Rock City Express caboose in 1950. Peyton's former home was purchased by Rock City in 1999 and converted into Grandview Lodge. *Rock City collection*.

Even without keeping regular office hours, Carter was still full of ideas, and in the early 1950s Rock City's advertising program exploded like the recently detonated atomic bomb. It began when Carter and Chapin realized that they could have a very powerful ally in the nation's growing number of motels and tourist courts. They discovered that they could provide, at no charge, such things as ashtrays and rubber doormats that read "SEE ROCK CITY," as well as full-color photos of Lover's Leap to hang in the rooms, and the motels would eat it up, since these were expenses they would have to pay otherwise. The real surprise came when Rock City discovered that the motels were just as willing to *buy* the advertising items. When Carter suggested that they sell the motels SEE ROCK CITY bath towels, someone tried to discourage him by telling him that souvenir-happy tourists would steal them in no time. "That's the whole idea!" Carter explained. As far as he was concerned, every home to which the stolen towels were carried would become yet another outlet for Rock City advertising.

Carter and Chapin also saw to it that their motel mentors were more supportive of their efforts than the tourist home Carter had encountered during his long-ago visit to Silver Springs. At one motel in the eastern section of Chattanooga, owner Zack Taylor proved to be just the kind of person Rock City loved to deal with. Taylor's motel had fewer than twenty rooms, yet it was one of the first in the area to be air-conditioned. Taylor would personally conduct his guests to their rooms and show them how to use the air conditioning control—and in his hand he would be carrying five Rock City postcards, to which he had already affixed the proper amount of postage. All the guests had to do was fill out the postcards and mail them. More often than not, the tourists would use the opportunity to brag about Rock City, Taylor's motel or both.

One of Rock City's biggest promotional triumphs was its utilization of restaurant guest checks. These checks were printed with Rock City ads on the backs, so that when the waitress placed the check on the table facedown, as was customary, the patron could not help seeing Rock City's pitch. These guest checks thrived in the days before fast-food restaurants became the feeding spots of choice. More than 340 million of them were sold to restaurants

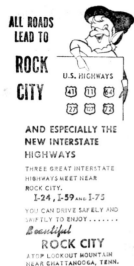

ALL ROADS
LEAD TO

ROCK

CITY

U.S. HIGHWAYS

AND ESPECIALLY THE
NEW INTERSTATE
HIGHWAYS

THREE GREAT INTERSTATE
HIGHWAYS MEET NEAR
ROCK CITY.
I-24, I-59 AND I-75

YOU CAN DRIVE SAFELY AND
SWIFTLY TO ENJOY . . . . . . .

*Beautiful*
ROCK CITY
ATOP LOOKOUT MOUNTAIN
NEAR CHATTANOOGA, TENN.

*Above left*: Helen Farthing of the National Service Agency poses with one of the countless prints of Lover's Leap that were destined to hang in motel rooms across the Southeast. *Rock City collection.*

*Above right*: Rock City was innovative in the use of the backs of restaurant guest checks for its advertising. This example comes from the late 1960s, when the "new interstate highways" were still something of a novelty. *Rock City collection.*

during the first attempt at this campaign, and it would continue for years to come.

By 1951, Rock City's advertising program had reached the point that it had to be established as a business apart from the attraction. The new agency was headed by Dick Borden, son-in-law of veteran Rock City employee Don Gault. Borden's arrival in the world of Rock City was rather convoluted. It began to take shape when Garnet Carter decided to build a luxury hotel in the vicinity of Lover's Leap (in retaliation for losing the Fairyland Inn, perhaps?). A group of downtown Chattanooga hotel owners, realizing that such an attractive addition would make their own business a wreck, came to Carter and assured him that they would fight fang and claw to keep him from going through with the project. Somewhat uncharacteristically of him, Carter let the idea drop, but he had

already sent for Borden and his wife Donna to leave their home in Arizona and come to Lookout Mountain to manage the hotel. Now, with no hotel to manage, Carter set Donna Borden up in the Rock City coffee shop and made Dick Borden the leader of the new Rock City advertising department, the National Service Agency (NSA).

At first, the NSA continued the motel and restaurant promotions that had already been started, but it stepped up its pace several hundred fold. Borden spent more time on the road than he did at Rock City, driving up and down the major tourist highways and visiting every motel, tourist court and restaurant. He kept detailed lists of the locations and memorized the owners' names, so he could give them a cheerful greeting upon his arrival. Borden's attention to detail certainly paid off.

Besides the aforementioned doormats, ashtrays, framed pictures, postcards and guest checks, motel lobbies and restaurant counters soon sprouted large, neat displays of Rock City brochures and wall clocks with the famous logo. The motel rooms now contained soap bars with imprinted SEE ROCK CITY wrappers (later, a full-color picture of Lover's Leap was added to the design). The soap proved to be as hot a commodity as the guest checks: motels paid a whopping two dollars for a case of one thousand Rock City soap bars, whereas normal motel soap wholesaled for around twelve

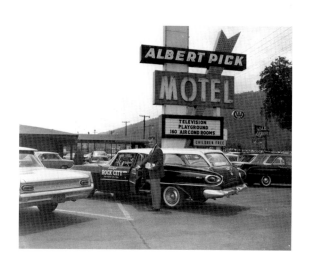

Advertising director Dick Borden spent more time on the road than he did at Rock City, visiting motels, restaurants and service stations and leaving promotional materials by the thousands. *Rock City collection.*

dollars for the same quantity. The motels found that, economically, it was beneficial for them to advertise Rock City.

Another common sight in roadside businesses was Borden's newest idea, the Rock City "mileage meter." These meters, manufactured in both aluminum and plastic models, contained a rotating drum on which were typed the mileages to various cities. The main interest of the meters was that each one was customized to fit the city in which it was to be placed. This necessitated a never-ending program of updating the meters, as highways (and later, interstates) changed the courses of the major routes. The mileage had to be calculated from each meter's location to each of the cities to be listed. This information would then be hand-typed and pasted onto the rotating drum, which also contained pictures of views in Rock City.

It was Clark Byers who came up with the most permanent of the decade's promotions. Byers had gotten back on the road after the war's end, and by the 1950s he had been painting barn roofs for so long that he could do it backward—or at least he thought he could. Just to break the monotony, he actually did try painting a sign backward, going from right to left, but when he finished he discovered that the word "CITY" had come out "CTIY." That broke him of that kind of experimentation in a hurry, but it did not mean he couldn't have other ideas in his paint can. Byers conceived the idea of building miniature barns with the prerequisite SEE ROCK CITY on the roofs

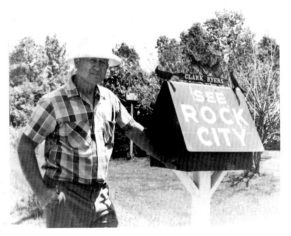

In the 1950s, Clark Byers came up with the idea of building mailboxes shaped like his famous Rock City barns. The postal service objected, so Byers converted the idea into the iconic Rock City birdhouse. He had the foresight to retain the original mailbox as his own. *Rock City collection.*

and selling them as mailboxes. The U.S. Postal Service didn't care much for this idea, claiming it was "against regulations."

Byers was undaunted. He took the prototype barn mailbox, punched holes in it and declared it to be a birdhouse instead. The Audubon Society did not have any regulations that would interfere, so a new advertising medium was born. Dick Borden recalled how the birdhouse promotion skyrocketed:

> *I found some small contractors down in Tiftonia, and they started building birdhouses for us. The roofs were made for us out of baked enamel. Then I got out with one of the boys from up here at Rock City, took our panel truck, and we went down to Jasper, Tennessee with the first half dozen birdhouses that were ever put up along the highway. Well, as we put them up, people started stopping: "Can we have one? We live right on the highway!" "I own a motel; can I have one?" So I came back and got Mr. Carter, and we went out in his Cadillac. I showed him the birdhouses and told him, "Now everyone's asking for them, and I'd just as soon go ahead with them." He said fine, so I got Abilities, Inc.—they hired disabled people—and got them started building the birdhouses.*

The red, black and white Rock City birdhouses spread like blackbirds, appearing on the lawns of motels, in front of service stations, outside restaurants and in other spots too small for a barn to squeeze into. In fact, the public image of the three words "SEE ROCK CITY" may owe its popularity more to the birdhouses than to the longer slogans that appeared on the barn roofs. Within a few years, the avian apartments had virtually replaced the barns as the symbol of Rock City. When a small, portable model was introduced for sale in Rock City's souvenir shop, tourists by the thousands carried the birdhouses back to their homes, causing SEE ROCK CITY to appear in areas never previously touched by the Gardens' publicity.

Besides motels and restaurants, the third major business that catered to highway travelers was the service station, and Rock City's promotions reached out to those establishments, too. The main vehicle for accomplishing this was the "strip map." Dick Borden explained how this worked:

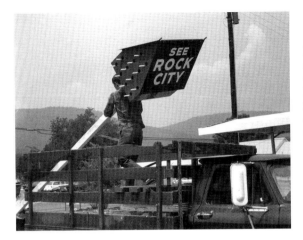

Rock City sent crews out to all the major tourist highways to install birdhouses on motel lawns, in front of service stations and anywhere else the red, white and black avian apartments could be placed. *Rock City collection.*

*This was a long, narrow sheet showing, for example, U.S. 41 all the way from Chicago, across the Everglades to Miami. We had one for U.S. 11 and one for U.S. 27 as well. They were strung on a string, and every service station had them. People were always asking distances, and the mileage was already shown on these maps. The station would just pull one off the string and hand it to them. We put out millions of those.*

Rock City again made the music scene late in 1951, when Tennessee Ernie Ford and the Dinning Sisters recorded "Rock City Boogie." Direct references to Rock City in the song were few, but it had a catchy tune and lyrics that began, "Atop Lookout Mountain, up in Chattanooga/ Everybody's doin' the Rock City Boogie..." The attraction also received brief references in other records of the same era. Rock City was mentioned, in company with Ruby Falls, in Tabby West's "Chat-Chat-Chattanooga," and rural comedian Bob Corley made a recording of his comedy monologue, *Number One Street* (a.k.a. U.S. Highway 1), which contained references to Rock City, as well as Silver Springs, Stuckey's and other Southern roadside fixtures.

A big publicity event was made of Rock City's twenty-first anniversary on May 21, 1953. On that date, there was no admission charge, and a festive atmosphere reigned. Shortly thereafter, a new promotion began, in which visitors could receive a free, framed

It is quite possible that the SEE ROCK CITY slogan may owe its popularity to the ubiquitous birdhouses even more than to the barns...which, as we have seen, usually featured more elaborate phraseology. *Rock City collection.*

color photograph of Lover's Leap by presenting a coupon that was printed in newspaper advertisements. Naturally, this also had an ulterior motive, as the photographs hanging in people's homes would continue to promote Rock City to all who saw them, every day of the year.

An era in Rock City's history ended on July 21, 1954, when Garnet Carter died at his home, Carter Cliff, at the age of seventy-one. He had not gotten his fervent wish to outlive his invalid wife, but Frieda Carter was exquisitely cared for during the ten years she would outlive her husband. Carter's passing was noted by newspapers and magazines across America. It seemed that even people who had never been within a thousand miles of Lookout Mountain had at least heard of SEE ROCK CITY. The best and most widely quoted eulogy for Carter had actually been written a few years before his death, but in the summer of 1954 it was published again, as it seemed to express everyone's sentiments perfectly:

> *God Almighty created Lookout Mountain and Garnet Carter dramatized it. He found and developed its vital points and places. The mountain that God gave charm of scenery amid rocks and rills became fourfold an attraction when Garnet Carter put his hands and his heart and his magic to add untold beauties made by hand to the transcendent beauty nature provided.*

*Garnet Carter's development of Fairyland profited him but little in money. Every penny and more realized from the sale of lots went into development after development. Later, when his talented wife aided him in creating a showplace of Rock City, he realized some profit, to which he was justly entitled. Money, however, is of little consequence to this man of the mountain. When the filthy lucre accumulates too rapidly he flings it into a wishing pond or builds something or other that flirts with his fancy. He is a creator, a builder, a buyer, a happy constructor, a developer of townships, golf courses, homes, anything and everything that will allure mankind and make happier the thousands who worship originality and the imagination that made it visible.*

After the death of its publicity-conscious founder, Rock City proved that it was still perfectly capable of promoting itself, thanks to Dick Borden and the NSA. Borden acquired a trailer that was shaped like one of Clark Byers's barns, loaded it with brochures and other promotional paraphernalia and drove off, leaving an even bigger impression at the stops he made. The birdhouses were by now front-runners in Rock City's outdoor advertising program and regular maintenance crews were sent out to keep them painted, cleaned and even disinfected to make the feathered inhabitants'

Dick Borden acquired this trailer shaped like a Rock City barn and loaded it up with promotional materials, creating quite an impression at every stop he made. *Rock City collection.*

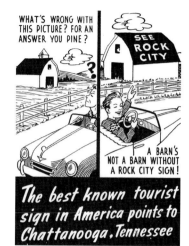

WHAT'S WRONG WITH THIS PICTURE? FOR AN ANSWER YOU PINE?

SEE ROCK CITY

A BARN'S NOT A BARN WITHOUT A ROCK CITY SIGN!

*The best known tourist sign in America points to Chattanooga, Tennessee*

The total number of Rock City barns peaked at approximately eight hundred during 1956. They could be found as far north as Lansing, Michigan, and as far west as Marshall, Texas. *Rock City collection.*

lives more pleasant. Byers and his crew were going full steam as well, and the total number of barns peaked at around eight hundred in 1956.

Dick Borden's duties were compounded by the fact that now Rock City itself was not the only tourist attraction operated by the company. Rock City had leased Rainbow Springs, a lovely natural spot located farther down faithful old U.S. 41 in Dunnellon, Florida. NSA was responsible for Rainbow Springs' publicity, as well as Rock City's, though there was never any attempt to give Rainbow the hard sell that was employed for its Chattanooga sister. Borden basically confined Rainbow Springs' advertising to within Florida, but with the number of motels and restaurants in that tourist-laden state, that was quite enough. The Rock City barns had always stopped in southern Georgia, but during the Rainbow Springs years, Byers kept things busy south of the border by painting a limited number of See Rainbow Springs barns.

Attention seemed to attach itself to Rock City like flies to flypaper during the 1950s. One high point came when NBC-TV broadcast an episode of the *Today Show* from the Gardens. Longtime Rock City employee Catherine Myers remembered that the network TV crew had to arrive at 4:00 a.m. to begin the complex setup for the show, and at that time of morning Lover's Leap (from which the opening

# SEE ROCK CITY

Even though the Rock City barns generally stopped at the Georgia/Florida state line, during the years that the attraction also operated Rainbow Springs near Dunnellon, Florida, Clark Byers and his crew prowled the Sunshine State's highways to paint SEE RAINBOW SPRINGS barns. *Rainbow Springs collection.*

was to be broadcast) was quite as dark as dark could be. *Today* host Dave Garroway had initial trouble adjusting to the unfamiliar surroundings, and shortly before airtime he accidentally made a grand dive into the goldfish pond. In addition to Garroway and his regular cast, the show included big band singer Helen O'Connell, who warbled her songs while standing on the observation platform with High Falls in the background.

A major new development in Rock City's advertising around this time was the debut of Rocky the Elf. For many years, Rock City brochures and souvenir booklets had been featuring the gnomes and elves that were so common in the Gardens, and on occasion a single elf would be spotlighted as a "host" of sorts. He would usually be seen in a red hat and pants, with a loud green shirt. According to Ed Chapin, the actual design of the character who would come to be known as Rocky was created by an Atlanta printer, Belfair Carter (no relation to Garnet and Frieda), who retained the red-and-green color scheme and gave Rocky a pointy beard and a shirt with his name emblazoned across the front. One of Rocky's first appearances was on a litter bag that was handed to each visitor upon entering the Gardens. Rocky's role in Rock City's promotions would grow with each passing year.

86

These plastic litter bags marked the official debut of Rock City's newest and most lasting mascot character, Rocky the elf. *Rock City collection.*

In 1956, Rock City published a dot-to-dot coloring book entitled *My Trip Through Fairyland Caverns*. The rise of Rocky and the appearance of this book proved that children were now being taken into major consideration by the Gardens' promotional wizards. Fairyland Caverns was one of the most hyped aspects of Rock City, and its appeal seemed unlimited. Alfred Mynders of the *Chattanooga Times* reported:

> *This columnist went through with two Californians. One of them said, "We have something like this in California. It is Walt Disney's Disneyland. There also we see the characters out of the fairy stories. But it is not as beautiful as this Rock City."*
>
> *What makes this succession of fairy tale tableaux so beautiful in Rock City is the fairy-like delicacy of the coloring, the lighting, and the re-creation of the beloved children and the animals and the butterflies and birds. Grownups are delighted by the sheer artistry of the scenes. Children who see them will never forget them, for here their beloved fairy people come to life.*

Yes, the times they were a-changin'. As the preceding article indicated, a new type of tourist attraction had suddenly sprouted:

the theme park, pioneered by Disneyland in Anaheim, California. A little-known fact is that Rock City played at least a small part in the creation of this competing class of tourist destination. Early in the 1950s, Walt Disney had undertaken a tour of the world's major attractions, ostensibly to get ideas for the type of park he did and did not want to build. Rock City was among the stops on his trip, and even though his exact reaction to it is unrecorded, Disney sent

Located at the exit from Fairyland Caverns, the Rock City gristmill was the final sight in the gardens. Unfortunately, it burned in 1999 and was not rebuilt; only the turning water wheel survives to mark its former site. *Rock City collection.*

the whole Chapin family free passes to the opening-day festivities at Disneyland. (For the rest of her life, Jessie Sanders firmly believed that Fairyland Caverns likely gave Disney the inspiration for the use of black light in Disneyland's famous rides Peter Pan's Flight, Mr. Toad's Wild Ride and Snow White's Scary Adventures.)

Walt Disney had conceived the theme park as an alternative to dirty, poorly kept amusement parks, such as those found at Coney Island, and, like so many of his other ideas, Disneyland and its format caught on with the public immediately. It would be a few more years before Rock City would directly feel the pinch of competition from theme parks in its own part of the country. There was another, larger change beginning to rear its ugly head, and it clamored for more immediate attention.

While in Germany during World War II, General Dwight Eisenhower had been greatly impressed with that country's system of superhighways, called the Autobahn. Now General Eisenhower was known as President Eisenhower, and he decided that the United States needed a system of Autobahn-type highways of its own. In 1956, the Federal Interstate Highway Program was implemented. The interstates, it was explained, would relieve the congestion so common on the old-fashioned U.S. highways. They would also allow drivers to see more scenery because the interstates would bypass small towns and strike out across the open countryside, which would be unmarred by advertisements.

It was that last part that made the tourism industry's blood run cold. As if it were not bad enough that scores of thriving restaurants and motels on the old highways would suddenly find their flow of customers squelched by the interstates, there was the threat that such establishments, and attractions such as Rock City, would no longer be able to advertise their presence. However, the interstate program was having enough trouble just getting started, so these concerns still seemed to be a part of the future.

In the meantime, an interesting, if somewhat minor, footnote in Rock City's history came when the Russian space program suddenly threw the world into the space age. It is amazing how many cartoonists and other jokesters got mileage out of the single concept of people reaching the moon, only to discover a sign reading SEE

ROCK CITY. This gag would be repeated in varying forms until the United States finally did put a man on the moon in 1969.

In the past, the tourist attractions in any given region had been subject to a number of petty rivalries, both real and imagined. We have already seen how Rock City and Ruby Falls had been raising their hackles at each other since the guide wars of the 1930s. The growth of the tourism industry had done nothing to make them kiss and be pals, as the two attractions battled each other for prime billboard locations along the highways. However, with the interstate threat a looming part of life, and the total number of tourists on the roads being greater than ever before, it seemed that now was the time attractions needed to be working together rather than against one another. This was the feeling behind the formation of the Southern Highlands Attractions (SHA).

SHA was officially established when its first meeting was held in Cherokee, North Carolina, on February 22, 1957. SHA's members were to consist of tourist attractions located in the southern mountains, defined as stretching from Virginia southward to Lookout Mountain. Each member of SHA would pay an annual fee, and these funds would be used to produce advertising materials that would promote the member attractions as a whole.

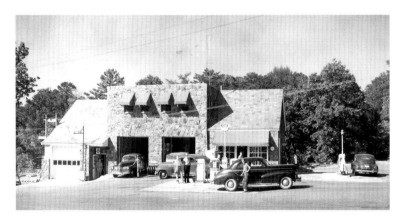

The gas station at the entrance to Rock City became headquarters for the Fairyland fire department in the early 1950s. In recent years, the original 1951 fire engine was discovered rusting in a field and was painstakingly renovated for display. *Rock City collection*.

Carl Gibson of Ruby Falls was elected to serve as the first president of SHA, and at that first meeting the following attractions were accepted as charter members: Rock City, Ruby Falls and the Lookout Mountain Incline, representing Chattanooga; the outdoor drama *Chucky Jack* and the Sky Lift, both of Gatlinburg; Virginia's Luray Caverns and Natural Bridge; and a host of North Carolina attractions, including Oconaluftee Indian Village, the *Unto These Hills* production, Fontana Dam, the Thomas Wolfe Memorial, Chimney Rock Park, Grandfather Mountain, Blowing Rock, the Tweetsie Railroad and another outdoor drama, *Horn in the West*. While other attractions would be added over the years, and some of the originals would drop out, most of these charter members make up the core of SHA today.

The attractions found that SHA provided many benefits that they would not have otherwise enjoyed. Each attraction had a display of brochures from all the others and also a framed map showing their locations. In a move that would have been almost unheard of in the old days, attractions often recommended each other to their patrons. Ruby Falls would suggest that their visitors "SEE ROCK CITY" after finishing their tour of the caverns, and vice versa. In a less public aspect, SHA also provided an organized group to appear before various state highway departments to request needed road repairs. This "united we stand" tactic would also see increased use when the big fight to eradicate roadside advertising came up in the future.

An unparalleled spirit of cooperation and camaraderie prevailed at the SHA meetings. If one or another of the member attractions was having some sort of problem, it would be brought out into the open and the other members would give helpful suggestions—based on their own experiences—for a solution. While some rivalries continued in private, at least publicly the various tourist attractions gave the image of all playing on the same team. Southern Highlands Attractions remains a vital part of the South's tourism industry today.

By this time, Jessie Sanders was on her own to work on Fairyland Caverns, her husband Charles having passed away around the time of Garnet Carter's death. She continued to add new scenes from

In 1958, Jessie Sanders conceived the idea of an addition to Fairyland Caverns that would feature all the famous Mother Goose nursery rhyme characters cavorting on a hillside topped by a giant castle. *Rock City collection.*

time to time and constantly tweaked and improved the existing ones, but by the late 1950s she had conceived a new idea of somewhat larger scale. She said that the beginning of her inspiration came when she saw a painting that appeared on the back cover of a book of fairy tales. The artwork depicted a medieval castle on a hill, while down below, Puss in Boots cavorted with a couple of other folklore characters.

Mrs. Sanders was fascinated by the concept, and one night soon thereafter, she had a dream that expanded on the idea. In her dream, she could see the castle on the hill, with a long, winding driveway, while the entire hillside was covered with nursery rhyme figures. She went to Ed Chapin and requested that she be allowed to build this Castle in the Clouds, as she called it. Chapin agreed that the idea was a good one, but he told his resident artist that there were just too many other, more pressing projects that needed attention at the present time. He assured Mrs. Sanders that as soon as he felt that it was time to begin such an elaborate undertaking, he would let her know.

One of the projects Chapin had in mind for Jessie was not even located at Rock City itself. The company had obtained the rights to revitalize Point Park's gift shop and museum, which had fallen into disrepair. Chapin's idea was to make the Lookout Mountain Museum into a place more explanatory of the area's history in prehistoric and Civil War times. Much was done to help this idea along, but some of the greatest accomplishments were Jessie Sanders's life-size dioramas depicting scenes from the mountain's

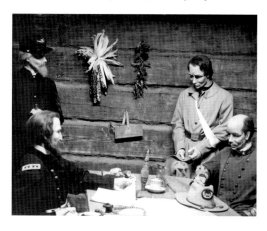

Proving that her sculpting abilities went far beyond storybook characters, in the late 1950s Jessie Sanders created these wax dioramas for the museum at Point Park. The white-haired gentleman is famed Lookout Mountain archaeologist J.P. Brown. *Rock City collection.*

past. These creations, including a prehistoric Indian family, a Civil War confrontation and the famed Lookout Mountain archaeologist J.P. Brown, gave her a chance to demonstrate her sculpting ability with figures that were infinitely more realistic than the fabled characters of Fairyland Caverns.

True to his word, once the museum project began nearing completion, Chapin announced that construction was to begin on Mrs. Sanders's dream world, which he renamed Mother Goose Village (homage, perhaps, to Frieda Carter's Mother Goose Village in Fairyland during the 1920s). To work out the dimensions and layout, Mrs. Sanders built a model of the landscape on a long tabletop in her studio. The model indicated the position of the castle, the winding driveway and the numerous valleys and ridges all around, along with semiabstract shapes to represent the various scenes. A huge, separate room was constructed adjacent to Fairyland Caverns, and a door was cut through. The door was then sealed up to await the "unveiling" of the project, still several years away.

Not much was said to the public about the new Mother Goose Village for the time being. Mrs. Sanders's work progressed quietly, while Rock City pursued other, more public promotions. Catherine Myers wryly remembered the day in May 1958 when Rock City published a newspaper coupon allowing the bearer to tour the attraction for free. Even though weather forecasts were bad for that particular date, the Gardens were packed to the limit. Then, the rains came. Rock City employees hustled through the crowded trails, passing out plastic rain slickers to the drenched denizens.

An offshoot of the baby boom, which had already done so much to boost tourism, was the revival of miniature golf during the 1950s. The new generation of courses were far more elaborate than Garnet Carter

Before beginning work on her full-sized Mother Goose Village, Jessie Sanders first devised its design and dimensions with this scale model in her workshop. *Rock City collection.*

had ever thought of making Tom Thumb Golf, featuring enormous concrete obstacles shaped like dinosaurs and other such monsters. Carter, however, was still recognized as the game's originator, and when the original Tom Thumb course at Fairyland was scheduled for demolition in the summer of 1958, the event made it into a respectable number of newspapers. By that time, only six holes of the original Tom Thumb course were left, and those remaining few were quickly razed to make room for tennis courts and a parking lot. Miniature golf would march on, but without Tom Thumb as part of the parade.

The year 1958 also saw the arrival of the dreaded problem that was to haunt Rock City and the whole tourism industry for a good part of the next thirty years. Along with the new federally funded interstate highway program had indeed come the threat of new federal regulations. As anticipated, the regulation that was causing the most sleepless nights for Rock City and its ilk was the one that, if put into effect, would prohibit all billboards and signs along the interstates. A newspaper account explained that this regulation would be possible because of the fact that the federal government was supplying most of the money to build the interstate highways. "While the government cannot force the states to ban advertising along the routes," the article said, "it has offered states that agree to regulation of highway advertising an additional one-half of one percent of the money granted them for the program."

To oppose this concept, Ed Chapin and his SHA colleague Carl Gibson, representing Ruby Falls, appeared on a TV talk show in November 1958 and stated their side of the case. The newspaper gave a condensed version of what they had to say:

> *Gibson and Chapin pointed out that the tourist business means between 30 million and 40 million dollars annually to Chattanooga, and that much of this business depends on highway advertising. Chapin said the city's hotels, motels, restaurants, service stations, scenic attractions and other business enterprises, their employees and the firms that supply them depend to a great extent upon tourist trade.*
>
> *He said the tourist business is based on impulse: "Chattanooga is not often the objective of the tourist; he stops here on impulse*

*when he sees something to interest him," Chapin declared. "We hope to be able to get him to stay for a day or a half-day."*

*Gibson and Chapin agreed that state control over billboard highway advertising is necessary, but they insisted that present laws, if properly enforced, would eliminate much that is objectionable. Gibson pointed out that numerous signs advertising "free" roadside zoos are illegal under present state laws, which he said are not enforced. They said they would favor more stringent controls over such advertising, but that complete elimination of advertising along the interstate system is unfair.*

*"People talk about the 'billboard lobby,'" Chapin declared, "but elimination of billboards along the interstate routes wouldn't make much difference to the advertising companies. They can put up all the signs they want inside the cities. It's the motels, restaurants, and attractions like Rock City that would be hurt... those that depend upon the tourist trade."*

This would be Rock City's messiest battle since the Lookout Mountain guide wars, but since the federal government—and within a few years, a president and a first lady—were involved this time, it was going to be a struggle that was even steeper than the slopes of Lookout Mountain itself.

These brochure racks could be found on hundreds of motel and restaurant counters by the end of the 1950s. Naturally, Rocky was prominently featured to point the way to Lookout Mountain. *Rock City collection.*

Since Rock City's advertising seemed to have penetrated practically every corner of the country by this time, in 1959 the company commissioned the nationally famous Gallup Organization to conduct a poll to determine (as the title of the study put it) "The Public's Knowledge Of, and Interest In Visiting, Rock City." This poll produced some interesting statistics. For instance, it found that nearly six out of every ten adults living in the East Central and Southern United States had at least heard of or read about Rock City. Out of these, proportionately more white-collar workers and businesspeople were familiar with Rock City than were farmers. This might seem somewhat surprising, considering the proliferation of Clark Byers's painted barns, but logical when one considers that most farmers did not have enough leisure time to travel very far down the highway.

Among those familiar with Rock City, nearly 7 out of 10 had heard of it through outdoor advertising—either billboards, barns, birdhouses or car bumper stickers. About 3,700,000 adults in the South and 2,500,000 in the East Central states had already visited Rock City; of the people who had not, 46 percent of those who had heard of Rock City said they would especially like to visit it. Out of those who had visited Rock City, 68 percent said they would like to visit it again sometime.

Another interesting response came when the interviewees were asked whether they thought the name "Rock City Gardens" or "Beautiful Rock City" was more appealing. They chose the first name by a margin of 50 percent to 34 percent. However, it seems that businesspeople and white-collar workers preferred "Rock City Gardens," while the farmers mostly picked "Beautiful Rock City." Perhaps life on the farm had given a somewhat unpleasant connotation to the word "garden."

One section of the poll was so unique (if a bit baffling in spots) that it is worth repeating here:

> *The public's "image" of Rock City is, at best, fuzzy. This survey finding may indicate that using just the name "Rock City" on outdoor advertising signs is not doing the best job possible.*
>
> *When adults who had heard or read about, but had never visited, Rock City were asked what they would expect to see at*

*Rock City, more than half, or 55 percent, said they would expect to see "rocks" or "rock formations." But one out of every four adults living in the two regions who had heard or read about Rock City said they couldn't say what they would expect to see. Out of adults who had never heard or read about Rock City, 42 percent had no idea of what they would expect to see.*

*To some adults, Rock City suggested offbeat things. One 21-year-old photographer's wife in Chicago said she would expect to see "miners." And a 34-year-old farmer living outside of Bayne Falls, Michigan, said he would expect to see "a prison camp." Other comments: "I'd expect to see a lookout tower." (Woman, 21, social worker, Chicago.) "Gardens, bears, and good looking women." (Man, 68, retired laborer, RFD, Tyler, Texas.)*

Among people who had visited Rock City, the top three attractions in the Gardens were almost unanimously chosen as Lover's Leap, the view of seven states and Fairyland Caverns. The main discrepancy was that men generally picked Lover's Leap as number one, while women chose Fairyland Caverns.

So ended the hoopla-heavy decade of the 1950s. The next ten years would see an increase of turbulence in many areas of life, but Rock City would be found holding its own in a rapidly changing society.

*Chapter 5*

# NEWS AND VIEWS

Rock City certainly did not waste any time in leaping feet first into the frantic activity that would come to dominate the 1960s. On January 7, 1960, the following press release was issued:

*About 1½ million people from every state in the Union and many foreign lands will be "charmed by the new look" as they step into the entrance building at Beautiful Rock City in 1960, E.Y. Chapin III, president, predicts. When the remodeling work now in progress is completed around February 1, the lobby at Rock City will have been completely transformed. An entire wall will be of plate glass, affording a view of the outdoor pool, which will be enlarged and extended beneath the plate glass picture wall and into the building. Chapin said the improvement will bring the "outdoors indoors" around the pool.*

*"The [advertising] program is aimed principally at arousing curiosity and remains for Rock City to sell itself to the folks who wander into its reception room, wide-eyed and wondering," the Rock City president said. "Because the picture window has been relied upon to finish the selling job begun by the barn signs, birdhouses, guest checks, folders, etc., a larger and more unique window setting was sought. Although anyone can buy goldfish and put them in a bowl to live contentedly, those in the pool at the beginning of the trail through Rock City have remained one of the most popular points of interest. The frog that spouts water just outside the window is also sought by many*

*who have heard about him from friends or relatives that have been here before them."*

Yes, it looked like things were going to be busy, all right. Dick Borden and his National Service Agency crew had a new idea to promote to the motels, too. This time it was a paper "glassine" wrapper to be placed over the drinking glasses provided in each motel room. With a red and black birdhouse, each wrapper encouraged the tourist to SEE ROCK CITY.

In 1960, Rock City's entrance was remodeled to include this pool, which brought "the outdoors indoors" by means of a goldfish pond that extended into the main lobby. *Rock City collection.*

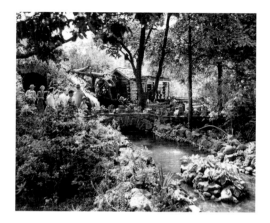

One Rock City veteran who survived for decades was the water-spouting frog (visible at far right). He had been a part of the original entrance pool adjoining the Sugar Loaf Shop from 1932 to 1937 and continued to spew his water until his retirement in 1992. *Rock City collection.*

By now, hundreds of thousands of those tourists were following that advice each year. The slogan was so familiar that Reverend William Garrett West of the First Christian Church of Chattanooga wrote and published a sermon entitled "See Rock City," which used many of the Gardens' views as metaphors for life. A north Georgia Boy Scout was taking a test, and after studying the problem of how to survive when lost, he turned in the following answer: "Well, about the best thing to do when you get lost is to find the nearest Rock City sign. That'll tell you how far you are from Chattanooga, anyway."

Another addition of the time was the Camera Obscura. A small building located adjacent to Lover's Leap, it contained a turret on which was mounted a camera with a ninety-degree-angle lens. The turret revolved and reflected the ever-changing panorama on a large glass table inside the building. Rock City held on to the Camera Obscura for a number of years, but it was never as successful as originally planned. It seemed that people who visited Lover's Leap were more interested in looking at the view themselves than in seeing just a reflection of it. The Camera Obscura quietly disappeared, and its site was converted into the Eagle's Nest, an additional observation deck that would, in turn, become the Seven States Pavilion in the 1990s.

The Gardens even became the setting for a mystery novel in 1960. Sterling Publishing of New York released *Mystery at Rock City*, a children's book by Christine Noble Govan and Emmy West. It

Rock City added the Camera Obscura in 1960. The panorama below Lover's Leap was reflected onto a table in the middle of the building, but more people were interested in looking at the actual view than merely a reflection of it. *Rock City collection.*

was part of a series of Hardy Boys–inspired stories concerning a group of youngsters calling themselves the Lookout Club. The plot involves a pair of crooks who ingeniously receive smuggled jewels inside a shipment of new figures intended for the Snow White scene in Fairyland Caverns. At the high point of the excitement, one of the malefactors shoots it out with the police from his perch in the middle of the Swing-A-Long Bridge as horrified tourists watch. Authors Govan and West apparently did much on-site research, as Rock City and its environs are depicted in amazingly accurate detail—even to the point of briefly mentioning the statue memorializing Spot, Garnet Carter's much-loved dog. Ed Chapin is thinly disguised as owner "Mr. Martin" in the story.

Fictitious jewel thieves aside, the real-life event that struck terror into the very heart of Rock City was the December 1960 announcement that the State of Tennessee was ready to subscribe to the government's plan for restricting billboards on that state's new interstate highways. If the law were enacted, signs in the immediate vicinity of interstates would be confined to informational and directional boards posted by the state. The argument grew heated early in 1961, but that was about the only thing hot during that winter. Lookout Mountain was crippled by a terrific ice storm, which caused Rock City to be closed for three days and many of the employees to be trapped at their jobs. Catherine Myers remembered standing at the head of the trail and hearing the loud noises as tree after tree succumbed and cracked under the weight of the ice. There

This selection of Rock City souvenirs and merchandise from the early 1960s includes the children's book *Mystery at Rock City*. *Rock City collection.*

was no permanent damage, but the gardeners certainly had their work cut out for them when replanting time came.

The weather could not possibly have been any colder than the outright hostile opinion held by increasing numbers of people about roadside signs. A survey showed that along the twenty-three-mile stretch of U.S. 41 from Chattanooga to Jasper, Tennessee, there were 879 signs. The newspaper groused:

> *In this forest of signs there is a multitude of shapes and sizes: big, middle-sized and little, square, round and oblong. There are red, green, black-and-white signs and some with hideous or fanciful color combinations. There are signs with correctly spelled legends, incorrectly spelled legends, with pictures, without pictures, professionally done and do-it-yourself jobs. In one eight-mile stretch, 72 signs advertising the same establishment were counted. In one 1,000-foot section, 14 signs proclaim the merits of various attractions.*

Regardless of the complaints, Rock City continued to whistle bravely. Ed Chapin predicted that 1961 would be Rock City's best year ever. His now-annual New Year's publicity release told the story:

> *Travel business in the United States increased 4.85 per cent for 1960, according to the National Association of Travel Organizations, and gains for 1961 should be equally high. Not*

*only are more people traveling, but also more areas and tourist attractions are trying to lure visitors off the highways. Tourists who come to see Rock City as a result of our promotion and advertising will benefit all of the Chattanooga area. Each tourist who visits here is a potential customer for the motels, hotels, restaurants, service stations, and other tourist-catering businesses of this region.*

*During 1961, Rock City Gardens itself will be the most attractive it has ever been for visitors. Now benefiting from a new planting program, the gardens will be graced by 500 hemlock trees as boundaries and scenic backgrounds. The attractive flagstone pathway has been greatly improved. The beautiful deer park has been renovated and redesigned to display the animals more vividly.*

*Several major improvements to Rock City Gardens are now in the planning stages, and announcement of them will be made during the coming year. One of these improvements will be of particular interest to children.*

January 1961 also saw the creation of a new advertising medium. Rock City (through the NSA) began publishing a monthly newsletter, originally titled *News and Views* and later renamed the *Rock City News*. This publication was not intended for public distribution; instead, as the introduction to each issue put it:

News and Views *is sent from Beautiful Rock City Gardens atop Lookout Mountain to Rock City's friends: the many folks who sell goods and services to Rock City, our friends in the motel, hotel, restaurant, and service station business, and hundreds of other people interested in the travel industry. It's our way of saying "Hey there" by mail between the times we get to visit with you in person.*

Rock City showed its allies that it was not going to pussyfoot around the billboard issue, either. On the first page of the first issue of *News and Views*, under a drawing of Rocky and the heading "Rocky Says," appeared the following declaration:

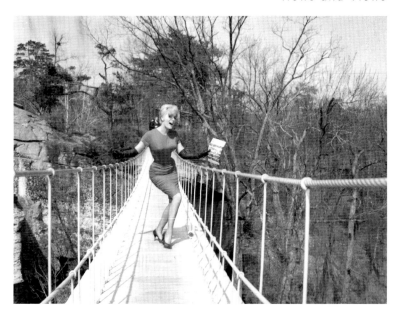

One celebrity guest at Rock City in the 1960s was June Wilkinson, a renowned *Playboy* model whose nickname was "the Bosom." In the bottom shot, E.Y. Chapin appears to be measuring Fat Man's Squeeze to ascertain that it can accommodate Ms. Wilkinson's famed physical assets. *Rock City collection.*

*At Rock City Gardens we live in one of the most beautiful gardens in the world, and we work every day to keep it attractive. We pick up trash and litter. We are constantly seeking to improve our wonderful scenic views. We have been awarded the Bronze Medal of Distinction by the Garden Club of America!*

*But all through Rock City Gardens we have SIGNS. These are neat, pleasant signs telling people what they are seeing, what they can expect to see, where to go next. Even magnificent Lover's Leap has a sign on it, and Lover's Leap is one of the most photographed views in America.*

*So tourists don't object to signs which are attractive. They enjoy them. They chuckle when they see signs like "Gnome's Overpass" and appreciate the signs which caution them to stay on the trail.*

*The same principles we've demonstrated here at Beautiful Rock City Gardens...where millions of people satisfy their quest for beauty...apply to our highways. We should all work to improve the beauty of our roadsides, but realize that signs on the highways help tourists to enjoy traveling.*

Each issue of the newsletter included a photo feature ("Rocky's Photo Album"), a column by Dick Borden reporting on his on-the-road promotions, one or two other small articles and a cartoon that almost always featured SEE ROCK CITY as its punch line.

Another organization's newsletter provided some good news in February, when *Travel USA*, the publication of the National Association of Travel Organizations, named Rock City as one of the top dozen tourist attractions in the United States. The others, in alphabetical order, were: Colonial Williamsburg (Virginia), Cypress Gardens (Florida), Disneyland (California), Empire State Building (New York), Freedomland USA (New York), Henry Ford Museum and Greenfield Village (Michigan), Luray Caverns (Virginia), Marine Studios (Florida), Mount Vernon (Virginia), Rockefeller Center (New York) and Silver Springs (Florida). Notably, more than half of the top dozen attractions were in the South. As an aside, Freedomland USA, a theme park built by former Disneyland bigwig C.V. Wood, is today cited as the biggest and most expensive failure

in the tourism industry—proving that being included on *Travel USA*'s coveted list did not automatically translate into success.

Rock City had been doing its best to court the travel organizations for a long time. One of the company's biggest projects each year was the Travel Writers' Tour, which fell under the jurisdiction of Dick Borden and the NSA. Borden once described the itinerary of a typical outing:

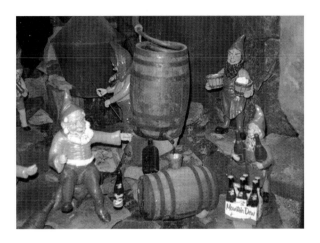

Advertisers frequently used Rock City for publicity shots, including Mountain Dew (top) and Sinclair gasoline (bottom). *Rock City collection.*

*We would host 25 to 30 top travel writers from magazines, AAA, newspapers, and so on. We'd bring them into Chattanooga and wine and dine them, having a barbeque and cocktail party at Ed Chapin's yard beside Lover's Leap. Then we would load them onto cruisers furnished by some of the wealthy people in Chattanooga, and we would take them up the river. We would go up on the boat with them, and the Jaycees would drive up the cars. Our local Buick agency was able to get new Buicks for the tour every year.*

*Then we would take over the cars with the travel writers, and go to Oak Ridge and Knoxville, then from Knoxville to Townsend, Pigeon Forge, and Gatlinburg; then, over the mountains to Cherokee, where we all became honorary Cherokee Indians; we would take in the drama [Unto These Hills] up there, then we would meet the tour from Georgia. They would take over, but we would go along with them and show them Atlanta, then on to Callaway Gardens. Mr. Callaway and his wife would always be there to greet them, and they would wine and dine everybody. The tour would end there, then everyone would return, some to Chattanooga, and others to Atlanta.*

All of that was ginger peachy with a cherry on top if you made your living as a travel writer, but for the host attractions, it still did not make the billboard opposition problem go away. Now matters became even more complicated because President John F. Kennedy threw his considerable influence behind the anti-billboard forces, giving them a frightening amount of power. The Chattanooga Convention and Visitors' Bureau issued a somewhat agitated report on the same day that Kennedy announced his position. It estimated that the travel industry in Tennessee would lose $31 million and ninety-one hundred jobs the first year if billboard advertising were abandoned. The bureau agreed that scenery was important in attracting tourists, but went on to say:

*Scenery in itself is not enough to build a travel industry. There are many sections of Tennessee with magnificent scenery that are suffering depressions. Tourists need lodging, restaurants, recreation facilities, and service stations as well as scenery. And firms need to advertise what they have for tourists.*

Dick Borden's column in the April 1961 issue of *News and Views* had the flavor of a politician's stump speech:

> *Now is the time of year when all of us are trying to get ready for our 1961 visitor season. We are anticipating all of the things so vital to catering to our visitors' needs. Although we are doing all this for our visitors, I think maybe we are forgetting one of <u>our own</u> basic needs: the protection furnished by our individual trade associations, both local and state.*
>
> *Here are some examples of things we need protection from: There is constant demand for complete elimination of all advertising along our highways. Some people have forgotten that travelers need to have information about places to stay, places to eat, and things to see.*
>
> *Governing bodies at all levels are casting their eyes toward the travel-serving industries as new sources of revenue. There is increasing competition for the consumer's dollar. People are being encouraged to buy everything from an extra television set to a backyard swimming pool. This means we've got to sell people on traveling. We just can't sit still and wait for folks to take to the road on a vacation trip.*
>
> *These are only three of the many reasons why we must <u>belong</u> to and <u>actively work with</u> our own trade associations if we are to state our own feelings in these legislative matters, if we are to meet competition from other industries.*

Amid the controversy, Rock City was increasing its signage even more. By now, the attraction was using two separate types of signs. Billboards were technically the temporary ones, printed on heavy paper and posted as most commonplace advertising signs were. The permanent signs were painted and maintained by Clark Byers and his helpers and remained in place all year long. (The barns and birdhouses were a special case, but for legal purposes they were lumped into this second category.)

The billboard campaign really bloomed in June 1961. Among the new crop of billboards was the first one to feature Rocky, who up to that time had been confined to smaller ads and souvenirs.

Now, Rocky was redesigned somewhat by Chattanooga artist Ben Hampton and grew to nine feet tall in a billboard that depicted the gnome painting flowers (a sort of Jack Frost in reverse) and proclaiming, "IT'S A GRAND DAY TO SEE ROCK CITY."

While many people did consider the billboards, neon signs, wildly designed drive-in restaurants and highway hoopla to be the epitome of ugliness, to the people in the tourist business such sights could give the heart a thrill. Dick Borden made one of his promotional excursions to that most garish of all garish Southern spots, Gatlinburg, Tennessee, and turned in the following observations:

> *You can't visit Gatlinburg without getting a good feeling about the tourist industry. Here's a town built for Americans on vacation, for the average family looking for wholesome fun at reasonable rates. This simple, successful formula is like a magnet for motorists, as all of us know who get business from tourists going to and from the Smokies.*
>
> *I've been trekking to Gatlinburg for years to supply hotels, motels, and restaurants with folders and other literature. It's a thrill to see those cars bumping bumpers, license plates from all the states like a political convention, Cadillacs and motorcycles, pickup trucks and plush camping wagons all in a row, with Rock City bumper strips on a good many of them!*

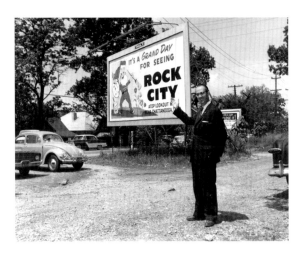

Chattanooga billboard executive Paul Gensheimer proudly shows off the first Rock City sign to feature Rocky. *Rock City collection.*

This was definitely the voice of a person who was in the tourist business!

The 1962 tourist season brought Rock City's most ambitious billboard campaign yet. Four new designs were introduced, three of which featured Rocky. All four used a striking color scheme. While the backgrounds were black, as befitted Rock City's traditional black-and-white logo, the lettering and figures on the posters were reproduced in flaming fluorescent colors. These loud hues caused the images to almost leap off the posters and grab tourists by the eyeballs, and this innovation won Rock City a second-place award in a national competition sponsored by the Outdoor Advertising Association of America.

There were still fears that the interstates would literally kill the businesses that thrived along the older highways, but a survey in the spring of 1962 showed that completion of the interstate up to that time had not hurt that "major lifeline for the Chattanooga tourist industry," U.S. 41. In fact, people in U.S. 41's tourist business reported that, at the interstate's present stage of construction, their establishments were actually seeing more traffic than before. Perhaps these folks can be forgiven for their false optimism. It was a case of "go ahead and laugh...*while you can.*"

Meanwhile, a new and lasting item had been added to Rock City's already-crowded souvenir shop. The Sawyer Company had introduced

This 1962 billboard was part of the group that was honored by the Outdoor Advertising Association of America. While the backgrounds were black, the lettering and artwork were reproduced in fluorescent colors. *Rock City collection.*

its View-Master toy in 1939, but it did not really become popular until the early 1950s. View-Master was simply a refined version of the stereopticon viewers that had been popular since the turn of the century, but it achieved its greatest popularity with color stereo slides of famous cartoon characters and scenic spots from around the world. The Rock City View-Master packet, with twenty-one stereo views of the Gardens and the scenes in Fairyland Caverns, continues to be sold today, with many of the same shots that were taken when the slides were first released. (The rocks in Rock City do not change their appearance from year to year, making this sort of longevity possible.)

As Dick Borden's column about Gatlinburg had indicated, a considerable portion of Chattanooga's tourist population was composed of families on their way to or from the Smoky Mountains. A 1963 folder designed especially for this market introduced a game intended to amuse the kids who might otherwise become bored with the drive. The game was called "Rock City Lookout," and its rules were as follows:

> *You're on the lookout for SEE ROCK CITY signs. One child or team takes the left hand side of the road, the other child or team takes the right. A birdhouse sign counts one point, a sign on a barn counts two points, a black-and-white sign by itself counts five points, and a sign with Rocky on it counts ten points. Remember, <u>only Rock City signs count in this game.</u> Teams can switch sides of the road at each new town.*

Rocky had become a star attraction of Rock City's outdoor advertising by 1964, when Jessie Sanders's long-awaited Mother Goose Village had its grand unveiling. *Rock City collection.*

It is little wonder that children were again being enticed toward Rock City—even being encouraged to ignore all other signs—because at long last Jessie Sanders's Mother Goose Village was nearing completion. Very little had been said about it up until that time, but the work had been continuous. Jessie vividly recalled the hours of labor involved in actually forming the crevice-filled hillside. The artist and her assistant, Johnnie Crumley, had to build the scenery from underneath, shaping it to fit the vision in Mrs. Sanders's mind. The first newspaper coverage of the coming attraction came in October 1963, when the *Chattanooga News–Free Press* ran a lengthy photo story on Mrs. Sanders's career, but it would be at least another six months before Mother Goose Village would be ready to open its gates to visitors.

There was some talk of the upcoming 1964 presidential election late in 1963, and Ed Chapin also announced that he would run for Congress in Georgia's Seventh District on the Republican ticket. Even though Chapin did not win the election, the situation led at least one newspaper writer to concoct a humorous fantasy in which politicians and Rock City sign crews slugged it out for the right to paint their respective messages on a baffled farmer's barn roof.

The year 1964 brought both the good and the bad to Rock City. The good part was that the New York World's Fair was drawing people up U.S. 11 to the Northeast, so Rock City and many of the other Southern Highlands Attractions throughout North Carolina and Virginia were able to profit from this migration. On a weekend in

The public rarely saw any of the hard work that went into creating the gigantic Mother Goose Village scene. Jessie Sanders and her assistants worked from underneath, building the hillside from the inside out. *Rock City collection.*

May, Mother Goose Village threw open its doors and began receiving visitors. As the most complicated addition that had been made to Rock City since the original construction of Fairyland Caverns, the Village became the focal point of Rock City's advertising for the next several years. All of this publicity helped Rock City to show a 10 percent increase in attendance for 1964.

The low point of the year came when Frieda Carter, the heart, brains and courage behind Rock City's very existence, passed away in August. Even though for many years she had been unable to participate directly in much of Rock City's development, it was always the knowledge that she had begun the whole thing that gave her an important place in every employee's heart. Ironically, her death did not receive anywhere near the amount of publicity afforded to her husband's passing a decade earlier, but then she had always been willing to remain in the background while the flashier Garnet Carter made all the headlines.

Around this time, Clark Byers decided to go into business for himself, even as he continued his sign-painting work for Rock City. After several months of work, Byers and a partner, Alva Hammond, had managed to develop Sequoyah Caverns, located near Valley Head, Alabama (about a half hour away from Rock City), into a place suitable for tourists. With Byers possessing a certain amount of loyalty to Rock City, a few inside jokes were sure to creep in. Sequoyah's billboards referred to the caverns as the "World's Ninth Wonder," an

This rather fetching early costumed version of Rocky takes aim during an unidentified travel show of the 1960s. *Rock City collection.*

obvious attempt not to overshadow Rock City's longtime billing as the "World's Eighth Wonder." And, deep in the heart of the caverns, a tunnel was labeled with a black-and-white arrow pointing into the inky darkness. The arrow read, "35 MILES TO ROCK CITY."

The advertising push for 1965 again centered primarily on Mother Goose Village and Rocky the Elf, but it was dealt an undeniably crushing blow that had been dreaded for years. After the death of President Kennedy, the new president's wife, Lady Bird Johnson, had taken up the anti-billboard campaign and enlarged it into a whole "Beautify America" program. Her ideas ranged even further than eradicating billboards from interstate highways; she also targeted architectural styles thought to be unattractive, such as the famous "golden arches" design of McDonald's red-and-white-tiled structures. With the backing of President Johnson, a new Highway Beautification Act (also known as the "Lady Bird Bill") was finally passed. It regulated signage and other aspects of not only the interstates, but all of America's highways, as well.

Clark Byers was forced to retrace his steps along the roadways, painting over the barn signs that were not located in commercial zones and so were in violation of the ordinance. Likewise, the birdhouses were considered advertising signs, requiring a separate permit for each side of the roof, so many of them flew the coop as well. The billboards and signs that remained were required to have licenses, and it was not surprising that the very first permit issued in the state of Tennessee was for a Rock City sign.

Attendance at Rock City again broke all records during 1966, but now it seemed like any such encouraging news was doomed to be counterbalanced by problems. The interstate really began to make its presence known that year, when I-24 was completed around the base of Lookout Mountain. Now Chattanooga was in effect bypassed, and with Rock City being the area's tourism leader, people naturally looked to it for advice. General Manager Margaret Dahrling warned that 1967 might bring a decrease in business for Rock City and the rest of the local travel industry. She pointed out that some way had to be devised to persuade tourists to exit from the interstate when they reached Chattanooga. A loss of only twenty-four tourists per day would be the equivalent of

During the early 1960s, Rock City even took on sponsorship of segments of the popular *Grand Ole Opry*, broadcast over WSM radio from the stage of the Ryman Auditorium in Nashville. *Rock City collection.*

losing an industry with a $100,000 annual payroll, according to Mrs. Dahrling's calculations.

With the monster finally invading the town, Rock City announced its three-point plan to save itself:

> *(1) An immediate program of action to make sure that informational signs on the interstate are understandable to tourists and encourage visitors to stop in Chattanooga.*
>
> *(2) Publication of new maps of the interstate system, which will make it easier for tourists unfamiliar with the area to find the proper exits.*
>
> *(3) Increased efforts to sell Americans in advance on seeing the Chattanooga attractions, through work with motor clubs, newspapers, magazines, and promotional organizations.*

These plans and the rise of the interstate meant that Rock City's traditional promotions in the restaurants and motels would have to change. Fast-food restaurants were the most common eateries to be found at interstate exits, and they had no use for such things as guest checks since there were no waitresses to be found. However, in the immediate vicinity of Chattanooga, even some fast-food restaurants permitted brochure displays for Rock City and its friends. Chain motels, such as Holiday Inn and Ramada Inn, now served lodging purposes, and while they initially welcomed some

of Rock City's items, they soon became too busy promoting their own logos to bother with some mountaintop tourist attraction. The independent mom and pop motels and restaurants along the old highways shriveled and died one by one as the interstates sucked the life out of their neighborhoods.

Rock City was also facing competition from the theme park segment of the tourism business. Walt Disney had not been alone in his enterprise for long. In 1961, the first Six Flags theme park opened in the Dallas/Fort Worth area, and in 1967 the chain arrived closer to Rock City's home turf with the opening of Six Flags Over Georgia in Atlanta. Six Flags Over Georgia even featured its own storybook "dark ride" (the offspring of Disney and, maybe, Fairyland Caverns). In this case, it was based on the famous tales of Uncle Remus. Besides that, shortly before Walt Disney's death in December 1966, the cartoon impresario announced that he was going to build a "super Disneyland" in Orlando, Florida, and call it Disney World. (His brother Roy eventually completed the project and renamed it *Walt* Disney World, so there would be no doubt as to whose idea it was.) These new attractions looked flashy and exciting, while suddenly Rock City and older tourist spots of its type seemed to pale in comparison.

While all of these problems weighed on its mind like the 1,000-Ton Balanced Rock, Rock City continued to diversify its activities outside the Gardens. In November 1967, the company purchased an FM radio station, WLOM (the call letters standing for "Look-Out Mountain"). The name of the National Service Agency was changed to Rock City Advertising, but its purposes and functions remained the same. Rock City had, for several years already, been operating the Fairyland Courts, a nearby motel. The motel's sign featured a gnome that somewhat resembled a cross between Rocky and one of the Seven Dwarfs.

The community of Fairyland, where the whole Rock City project began, was finally incorporated in 1968, taking the legal name of Lookout Mountain, Georgia. Although some residents would continue to refer to it as Fairyland, the move was symbolic of many of the changes that were taking place. During 1968, Rock City lost two of its most influential employees, one to an accident and one to retirement.

Clark Byers was still on the road when not at Sequoyah Caverns, although by now his work mainly involved repainting existing signs rather than creating new ones. In 1968, he went to retouch a Rock City sign on U.S. 41, about seven miles east of Murfreesboro, Tennessee, and received quite a shock—literally. Climbing up to the sign, he noticed that the paint had done an unusual amount of peeling in one particular spot. Byers couldn't figure out why at first, but he soon found out the reason. The wind from a passing truck blew some low-hanging power lines against the metal sign, sending seventy-two hundred volts of electricity through Byers's body. His hair was ablaze, and his left side was totally paralyzed, but he managed to hold on with his right hand while his assistant (who had been standing on the ground and was not injured) got him down and to a hospital.

Although Byers later recovered with no permanent aftereffects, the accident closed the chapter on the original Rock City sign painter. Unable to work and keep up the payments on Sequoyah Caverns during his recuperation, Byers was rescued by his longtime employer. Rock City bought the caverns from him and transferred Dick Borden from his Rock City Advertising duties to be manager of the cave. The maintenance of the barn signs and billboards was taken over by B.D. Durham and, later, Tommy and Lynn Moses and Jerry Cannon.

That same year, Jessie Sanders remarried—her new husband was Michael Schmid—and decided that at age sixty-eight, the time had come to retire from her work in Fairyland Caverns and Mother Goose Village. Since the Village's opening, she had continued to add new scenes as her imagination dictated. Among the last ones she created before her departure were the Three Little Kittens and the Little Girl Who Had a Little Curl. (Even with her twenty years of work, there were some classic stories that Jessie never got around to depicting; ironically, one of those was Puss in Boots, a character that had been a part of her original Mother Goose Village inspiration.) Mrs. Schmid would return to the Gardens occasionally to serve as a consultant and advisor to her various successors.

With Clark Byers now out of commission, his son Jimmy began to do some creative things for Rock City. One of his projects was a

This giant billboard, popularly known as the "world's biggest birdhouse," was erected over Chattanooga's Broad Street in 1968. *Rock City collection.*

billboard that became known as the "World's Biggest Birdhouse," located on Broad Street at the foot of Lookout Mountain. Rising sixty feet above street level, the huge sign became a landmark. A car dealership on the opposite side of the highway advertised itself as being "across the street from the world's biggest birdhouse." Eventually, because of changes in property ownership, the giant sign was moved to the other side of the street and the car dealership found itself "*underneath* the world's largest birdhouse."

Many of Rock City's employees, past and present, got together for the opening of Rock City's new restaurant, the Saddle Rock Inn, late in 1968. This was an expansion of Rock City's existing coffee shop. Its most unusual feature was that it was built around and over an enormous rock formation that sat to the right of the old 1946 coffee shop. Even so, much of the formation had to be blasted away to make room for the foundation and other construction, but the part that was preserved was certainly unique enough.

By now, the United States was fully involved in a controversial conflict in Vietnam, and, for all the tragedy associated with it, some of the soldiers managed to keep their senses of humor intact. Certain post exchange buildings in the Southeast Asian jungles mysteriously grew black-and-white signs on their roofs, generally reading "SEE

Rock City's new restaurant was completed in 1968. As you can see, it was built around and over a huge formation that sat next to the former facility. *Author's collection.*

ROCK CITY: ONLY 13,400 MILES TO LOOKOUT MOUNTAIN." Several Rock City birdhouses found their way into this hostile territory as well, spreading the message—and, perhaps, making some soldiers feel closer to home, which seemed very far away indeed.

The 1960s gasped its last when a man finally really did reach the moon in July 1969. This prompted one newspaper writer to drag out an old chestnut of an idea, one that from now on would not see near the exposure it had during times when more was left to the imagination:

> *What we saw on television was, believe it or not, screened to a degree so that NASA could maintain necessary control over events and public reaction to them. We saw the astronauts walk on the moon and we had one-way chats with them via TeeVee as they went up and came down.*
>
> *Curtis Willis, our reliable source of information here at the [Alexander City] Outlook, reports that when Neil Armstrong wandered out of camera range for the first time, before Aldrin emerged from the space craft, he made a startling discovery. There, planted firmly in the dark moon dust, was a structure on stilts, closely resembling a birdhouse. Curt says that what NASA isn't telling us is that when Armstrong drew closer, he could clearly read the inscription atop the structure: SEE ROCK CITY.*
>
> *Yes, Virginia, there is a credibility gap.*

## Chapter 6

# WASN'T IT WONDERFUL?

By the time the 1960s morphed into the 1970s, the tourism industry was facing its own midlife crisis. The interstates were the factor most responsible for the changes at hand, but there were others. The baby boom children who had first caused the tourist explosion were now primarily divided into two factions. One group was found in Vietnam, fighting in the jungle, and the other group was in the United States, fighting on college campuses. It was an era of hard feelings on both sides, and the general atmosphere was one that was not all that conducive to jolly, carefree family outings. Yet, Rock City and its compatriots pushed onward.

In January 1970, Ed Chapin announced the appointment of his oldest son, E.Y. Chapin IV, to the post of assistant to the president. E.Y. IV, known as "Chape" to distinguish him from his dad, had been serving as general manager of Rock City's radio station, WLOM. Upon joining Rock City proper, it was specified that Chape was to assist in long-range planning for coordination and development of the corporation's various enterprises, which at the time consisted of the Gardens, WLOM, the Rock City Restaurant, Fairyland Courts, the Lookout Mountain Museum, the Rock City Texaco station and Sequoyah Caverns.

Chape's official duties were to include "research and planning in areas involving both current and future development of Rock City Gardens and the allied companies." One of those allied companies got some good news that spring, when Dick Borden talked Kampgrounds of America (KOA) into building a new facility at

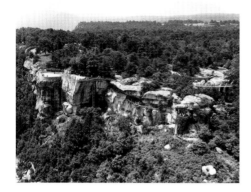

Tourists rarely, if ever, got to enjoy this viewing angle of Rock City's location; that is, unless they were in one of the hot air balloons the attraction employed in the early 1970s. *Rock City collection.*

Sequoyah Caverns. The new KOA Kampground gave Sequoyah's entrance a striking visual feature in the form of KOA's standard A-frame headquarters building, a truly eye-catching structure.

Rock City's advertising literally climbed to new heights during the summer of 1970, with the debut of the first in a series of Rock City hot air balloons. The seventy-five-foot balloon was piloted by Randy Rogers, while skydiver Bill Bolton attracted further attention by jumping out of it. The intrepid duo barnstormed their way through several states in their SEE ROCK CITY balloon.

The hot air balloon was one of the first promotional gimmicks devised by Chape Chapin in his new capacity. He said that he got the idea one evening when he and his wife were having dinner at the Fairyland Club. Looking down into the valley, the couple saw a colorful balloon rising toward them, and the spectacular sight became Chape's inspiration. Rock City would advertise its way through several different balloon designs during the next few years. The promotion was much touted as Rock City's newest modification of the barn roof idea, but it never quite reached the national fame of its rural predecessors.

The early 1970s were, by any gauge, an era of disillusionment and cynicism, and this attitude was too pervasive for even Rock City to avoid. A *Chattanooga News–Free Press* staff writer, Chris Segura, visited the Gardens in October 1970 and gave a report on the somewhat changed attitude of the tourists. It is a bit lengthy, but nevertheless important for what it says about the new mindset of the era:

*"I had heard about it, you know, but I thought it was just a bunch of funny rocks," one tourist said to a fellow lensman at the famous attraction on Lookout Mountain.*

*"Right," the second camera-equipped man said, his daughter tugging on his trousers. "I didn't even want to come."*

*Click...click...click. They went on. The steady stream of spectators slowed at the deer park. Watching the deer was almost as interesting as watching the deer-watchers. One woman made a much-heard comment upon seeing the Austrian animals. "Oh, they're so beautiful. I don't see how they can kill them with a gun," she said. A tall, sunburned man, apparently not in the company of the woman, looked at her with what can only be described as distaste. "You know, even in the open season, I can't see how they do it. They kill them and put them on their cars." The big man silently pulled his wife away.*

*A little boy wanted to see the state lines along with the states from the observation point. His mother tried to explain. Finally he gave up and became interested in the goats huddled under the precipice. One of the "goats" was a deer. "That one's a deer," his mother said. The little boy regarded the animal with suspicion. "Goat," he said. Obviously his faith in the Establishment had been shaken when his mother did not come up with a plausible explanation for the absence of state lines.*

*Two couples, casually dressed in sandals, sweatshirts, and fringed leather jackets, took turns taking pictures of each other posed just beyond the PLEASE STAY IN THE TRAIL signs.*

*Photographers slowed the tourists up considerably by crowding the displays in the man-made cavern. The coral plastered on the ceiling of one of the displays made one wonder what Florida looked like before it was raided. A strikingly beautiful, platinum blonde woman provided a spectacular sight herself, as the fluorescent lighting was caught in her elaborately arranged hair.*

*A scholarly though shabby-looking young man remarked to his buxom companion on the origin of the nursery rhymes displayed on luminous plaques. "Have you ever read these things before they were cleaned up?"*

*"No," she replied.*

*"They're filthy. Most of them were written as satirical pieces about actual personages. Take this one, for instance." He indicated the verses beginning with "Froggy Went A-Courting." Happily his voice trailed off into the piped-in children's songs. Blasphemy was ended.*

*"Wasn't it wonderful," another woman said to her husband, who was carrying a sleepy two-year-old.*

*"Yeah...great," the man replied.*

*"If it wasn't for the baby I'd go back through." The man looked at her in a strange fashion and did not reply. They walked through the turnstile.*

So, what ever had happened to those halcyon days of yore, when visitors remarked that Rock City was better than Disneyland? Many people were asking that question at the time, as the lifestyle that had seemed so familiar and so secure was suddenly crumbling all around, like a half-forgotten dream. But there were those who at least attempted to pretend nothing was wrong. In February 1971, one of the squeaky-clean couples from ABC-TV's *The Dating Game* received a trip to Chattanooga and Rock City as their prize, and the city rolled out the red carpet for them. Danny Poor and Cathy Houston, along with their "chaperone," Diane Sabourin, appeared to have a royal time on Lookout Mountain.

Rock City made an interesting snatch at its own history when artist James B. Noble completed a thirty-two- by fifty-two-inch oil painting of Lover's Leap as it would appear if seen from midair, one hundred feet out from the face of Lookout Mountain and one thousand feet above the valley floor. Someone had the bright idea of framing the painting with lumber from one of the original Rock City barns. Unfortunately, the very first barn at Kimball was long since demolished, a victim of the construction of I-24. But the owner, Cecil Smith, recalled that he had saved one of the oak planks from the old barn and had used it in another building. Locating the board, Smith cheerfully donated it to Rock City, and the frame was constructed. The painting and its one-of-a-kind frame were placed on display in the Rock City Restaurant.

Rock City's annual Christmas display started out slowly in the early 1970s. Here, jolly old Saint Nick warms himself by the lobby fireplace before setting out on his Yuletide rounds. On the mantel is Rock City's cover appearance on the April 25, 1960 issue of *Life* magazine. *Rock City collection.*

The attraction continued to come under repeated attacks from environmentalist groups who claimed that SEE ROCK CITY signs were a major part of the aesthetic blight along the country's highways. Even the Garden Club of America, which had presented the Bronze Medal of Honor to Frieda Carter in 1933, reversed its position, saying that it was no longer supportive of Rock City's efforts. The club stopped just short of threatening to take back its plaque. All of this negativity inspired a most unusual publicity stunt in the summer of 1971. Rock City drew newspaper coverage by removing one of its billboards located on U.S. 41 between Chattanooga and Guild, Tennessee. In the billboard's place, the company planted an evergreen tree in the name of highway beautification, with a plaque telling the reason for the tree's existence. Some of the environmental crusaders sneered that removing one Rock City billboard was similar to removing one grain of sand from Miami Beach.

A more lasting tradition began when Rock City presented its first annual Christmas display for the 1971 holiday season. The theme that first year was "Christmas in Fairyland." In later years, it would be modified to "Legends of Christmas" and then the "Enchanted Garden of Lights." The *Chattanooga Times* described Rock City's initial attempt at Yuletide décor:

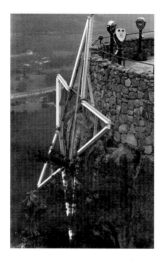

An enduring part of Rock City's Christmas décor was this huge lighted star that was hung annually from the retaining wall at Lover's Leap. *Rock City collection.*

*Walking toward the main building, visitors are greeted by a gigantic glowing tree. Each of the entrance doors bears a beautiful green wreath, and the inside of the lobby is decorated in appropriate holiday trim.*

*The first, and perhaps the most beautiful, of the Christmas sights along the scenic route is a magnificent nativity scene in life-sized wood carvings. The figures are set among the natural rock, and the effect is moving and authentic. One visitor who had been to the Holy Land remarked that the setting for this nativity scene is very much like the actual scenery where Christ was born.*

*The next Christmas scene is Santa's Reindeer Park. Actually, the rare albino deer are in the park all year long, but an authentic sleigh and the names of Santa's deer have been added for the Christmas season.*

*To the entrance of Fairyland Caverns has been added a huge "Welcome to Christmas In Fairyland" sign. The first room upon entering the caverns is the Diamond Corridor, which has been renamed "Mrs. Claus's Parlor" for the holidays. Inside the room a rosy-cheeked grey-haired Mrs. Claus greets each and every little visitor. Down the steps from Mrs. Claus's Parlor is Santa's Room, and there the jolly fat man awaits each child.*

*In the famous Mother Goose Village, where all of the best loved nursery rhyme characters are depicted, Santa's sleigh is seen flying to the magic castle. Little Jack Horner sits eating his Christmas pie, and all the other "little people" are decked out in their holiday best. After the tour is completed, each child may pick a piece of candy from the candy tree inside the Rock City Restaurant, which is also decorated for the season.*

One unexpected response to the trauma of a changing society was a rise in nostalgia, as many people began to seek solace in memories of the past. Movies such as *American Graffiti* and TV series such as *Happy Days* reflected this trend. In 1973, Maxine Thompson, a writer for *Georgia* magazine, penned an eloquent tribute to the old, bypassed highways with which Rock City's advertising was by now so closely associated. Ms. Thompson's piece read in part:

*With the furor being raised about giant billboards all but wiping out the scenery along our highways, especially the newer interstate routes, a ride along one of the older roads shows that the advertising agents of grandpa's day did a pretty good job of using what they found available.*

*Along on U.S. Highway 41, for example, which slices through Georgia from north to south, messages on barn tops, barn sides, and even dilapidated cabins-turned-barns still shout at the passerby to SEE ROCK CITY, SEE SEVEN STATES FROM LOOKOUT MOUNTAIN, and SEE RAINBOW SPRINGS in giant letters.*

*It doesn't pay to ride along this or some of the other older roads in the state while you're hungry. Hand-painted signs nailed to trees regale you with promises of "Fresh Peaches," "Country Hams," "Pecan Candies," or "Pit Bar-B-Q," along with souvenirs and gifts. They start giving the distance in miles, then in hundreds of feet, and finally in feet, until the drooling driver is led almost by the hand to a roadside stand loaded with fresh fruit, or perhaps a closed and boarded-up old building that represents a once-thriving business killed by the new interstate highway a few miles away.*

> *Unlike the sheared-clean expressways, though, these older roads treat the tourist to the near-forgotten sight and smell of Seven Sisters roses spilling over a sagging fence or the heavenly perfume of a tall, dew-drenched cape jasmine nestled against the corner of a deserted shack. Gnarled chinaberry trees that once played host to a generation of boys and tomboys who swarmed over their limbs now seem to droop their umbrella-shaped branches in loneliness. A solitary chimney, all that is left of a home that heard the ring of laughter and saw the tears of sorrow, is decorated with swirls of kudzu vines and a brick company advertisement.*
>
> *Don't ride over one of these roads when you're in a hurry. Take time to browse, to read the faded old signs on the barns. One of these days the last one of them will complete its crumble into decay. When that happens, a segment of history will fade away.*

Rock City dropped a bombshell on the nation's reborn nostalgic awareness in the spring of 1974, when Ed Chapin suddenly made the announcement that the Gardens were going to discontinue *all* forms of outdoor advertising, except simple directional signs. The official statement read, "Rock City Gardens is an environmental attraction, and our decision not to erect any more billboards is in keeping with the environmental consciousness of the times." It explained that not only were no new signs going to be created, but the leases for the existing ones would also be allowed to expire—"on a selective basis," a loophole that was conveniently ignored by the media. It goes without saying that this so-called moratorium did not last long, and it was soon forgotten by everyone involved. At the time, though, it probably caused Rock City to receive more free advertising than it would have with all the billboards and barns put together.

In conjunction with its announcement, Rock City conducted a contest for artists to paint their visualizations of SEE ROCK CITY barns in oils, watercolors and graphics. This was seen as a good way to preserve and document a part of the American roadside landscape that was rapidly fading, moratorium or no. The eventual winner of the art contest was Memphis watercolorist Georg Shook, who received the $1,000 first prize for his work. Oddly, the winning

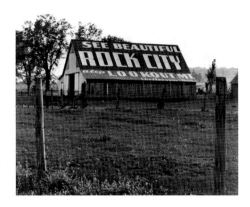

When Rock City made news in 1974 that it was going to discontinue all forms of outdoor advertising, this photo of one of the few remaining barns was distributed via wire service to newspapers nationwide. *Rock City collection.*

painting depicted a barn with a *white* roof and the Rock City lettering in *black*—an interesting, if improbable, color reversal.

The advertising "ban" also had an effect on twenty-two-year-old Catherine Britton, a graduate assistant in the Music Department of Michigan State University. She was reminded of a poem she had written some years earlier, when she was in a high school honors English class in Kingsport, Tennessee. She located the poem and sent it to Ed Chapin, and he was so impressed that Rock City saw to it that the verse got widespread newspaper publication. It went like this:

### FIRST THINGS FIRST

*Someday I want to take*
*A long long journey*
*Down a never-ending pathway—*
*A lane that is covered*
*With cool green moss*
*And tiny flowers*
*And which is shaded*
*Along both sides by a*
*Thick green wall of*
*Trees—*
*A long narrow parkway*
*Hedged with tall green*
*And cooled by the slanting light*

*That filters through the branches*
*Which are softly sighing*
*In a gentle breeze—*
*A simple roadway*
*Unmarred by signs and*
*Billboards and litter barrels*
*And Dairy Queens and*
*Perfect in its simplicity.*
*I want to find a road*
*That is green and soft and silent*
*And travel it forever*
*In a perfect state—*
*But first I want to*
*See Rock City.*

Amid all the hue and cry, Rock City had undergone another change that was far less visible to the public. During 1974, Ed Chapin had very quietly moved into the position of chairman of the board for Rock City Gardens, Inc., and son Chape had become the new president of the company. Dick Borden had also returned to Rock City, having left Sequoyah Caverns in other capable hands in 1973. The Rock City Advertising office had closed its downtown Chattanooga location (i.e., the old National Service Agency building) in the meantime, and it was now located above the Texaco service station at Rock City's entrance. Borden jumped right back into Rock City's advertising with gusto, even though the old-fashioned motel and restaurant promotions had, by and large, been discontinued by this time.

In a continuing effort to improve its image among those who criticized Rock City for the amount of its outdoor advertising, in November 1974 the Gardens made yet another announcement:

> *In support of President Gerald Ford's energy conservation mandate, Rock City Gardens has voluntarily pulled the plug on all of its lighted billboards in the Chattanooga area. The action will conserve approximately 16 tons of coal, according to Chattanooga Electric Power Board estimates.*

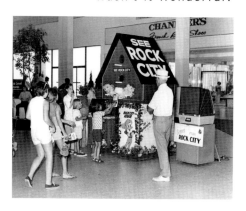

Changing times meant changing forms of advertising as well. The *Rock City Revue* puppet show appeared at malls and shopping centers, where the characters passed out tourism literature to the younger set. *Rock City collection.*

*Rock City Gardens President E.Y. Chapin IV said an outdoor advertising company was instructed to turn out the lights on eight illuminated bulletins for five fall and winter months. In addition, two directional signs with lighted arrows will be darkened for the cold-weather period.*

Always on the prowl for new promotional outlets, Rock City began eyeballing its own history as a source of publicity. The company commissioned its public relations office to produce the manuscript of a biography tentatively entitled *The Life of Garnet Carter*. The book was completed early in 1975, but for some reason it was never published. The story of Rock City took up only a small portion of the manuscript, which focused primarily on Carter's early life and the Fairyland/Tom Thumb Golf projects. However, the writers did do an amazing amount of research, interviewing many longtime Rock City employees and associates of Garnet Carter—a large number of whom would not live for too many years thereafter.

Throughout the years, Rock City's logo had been simple, basic and unmistakable: white block letters against a black background, period. This, of course, had originated with Clark Byers's cost-saving color combination chosen for the barn roofs. By 1976, the feeling was that the Gardens needed a more distinctive trademark, one that would give unity to its various forms of advertising. An Atlanta commercial artist, Steven Rousso, created a logo that seemed to fit the bill. The familiar SEE ROCK CITY now appeared in a more

"fancy" typeface and, more often than not, was accompanied by a large, colorful rainbow—a popular design element in the late 1970s—that arched over the lettering. The new "rainbow logo" was added to the attraction's billboards (which—surprise!—had not been discontinued after all). These billboards often sported Rock City's newest advertising slogan, "FOLLOW THE RAINBOW." (If Rock City had still been running Rainbow Springs at that time, the new logo would have made for some interesting co-branding.) On the signs, the background remained its traditional black, and the new lettering was outlined in white. The rainbow was the only splash of color on the signs, outside of an occasional appearance by Rocky.

Meanwhile, back up on the mountain, ever since Jessie Sanders Schmid's retirement in 1968, the Rock City gnomes and the denizens of Fairyland Caverns had been the responsibility of the Gardens' maintenance department. More than one person had had the task of looking after them, making sure they were painted and kept in reasonably good repair. The imported German gnomes were made of labstone, which was more durable than plaster of Paris, but their advancing age frequently made repairs necessary.

During 1977, artist Kenney Saylor took on the job of caring for Rock City's inanimate citizens. Between keeping their colors bright and their arms and legs attached, he even found time to create some new scenes for Fairyland Caverns, including the Gnomes' Gold Mine and Baa Baa Black Sheep dioramas. Saylor's creations

In the late 1970s, a colorful rainbow was added to break up the monochromatic monotony of Rock City's black-and-white billboards. *Rock City collection.*

were done so closely in the style of Jessie Sanders's originals that they blended right in as if they had always been there.

Rock City acquired some new property, as well as this new employee, in 1977. The full details were reported in the *Chattanooga News–Free Press*:

> *Rock City Gardens has purchased some 130 acres at Blowing Spring in Chattanooga Valley, including two pre–Civil War houses. The property includes the Mrs. Robert Wert home, which sits on a knoll by a large field just south of the Tennessee-Georgia line.*
>
> *Rock City has no specific plans for the acreage for the next several years "except to keep it in woods and open field." The Lookout Mountain attraction wanted to preserve the woodland scene from its "Lover's Leap," which overlooks the tract.*

Rock City observed its forty-fifth anniversary on May 21, 1977, with the unveiling of a plaque commemorating the work of Garnet and Frieda Carter. Newspapers explained that the plaque was replacing an older one that had been dedicated in 1953 (undoubtedly at the twenty-first anniversary celebration). That first plaque had been set into one of the Gardens' perimeter walls, which had since been removed to facilitate expansion. The ceremony was attended by five generations of the Chapin family, as well as some veteran employees. An honored guest was Dyer Butterfield, one of those who had been present on Rock City's opening day in 1932. The mayors of Lookout Mountain, Tennessee, and Lookout Mountain, Georgia, were on hand to give an official flavor to the affair.

It was nice that the Carters' work was being honored in the gardens that they created because the famous Rock City barns were rapidly becoming a thing of the past—and it had nothing to do with the ill-fated "moratorium." In 1977, there were only 152 of the once 800 SEE ROCK CITY barns left in the entire nation. Some of those were being considered for Historic Landmark status, but many of the others would disintegrate into ruin in the near future. Of course, no new barns were being sought out. Clark Byers was in retirement in Rising Fawn, Georgia, and his immediate successor, B.D. Durham, only needed to give an occasional touch up to the existing barns.

For many years, Rock City continued to jointly operate Sequoyah Caverns at Valley Head, Alabama, which had been developed as a tourist attraction by barn painter Clark Byers. *Rock City collection.*

The billboards continued to face problems of their own, as the Federal Highway Administration debated whether it was legal for businesses to cut or trim trees and other plant growth that was obscuring their signs along the interstates. As expected, representatives of both sides of the argument showed up in Nashville to state their views. The *Chattanooga Times* reported on this latest round:

> *Outdoor advertising company representatives argued that growth obstructing both the conforming and the nonconforming billboards should be cleared. Otherwise, they said, they're being deprived of their property through "condemnation." They were joined by a number of operators of businesses catering to tourists. These operators said billboards are vital to their business.*
>
> *A representative of Stuckey's, the operator of gift and snack shops, said business at those establishments dropped as much as 30 per cent when billboards directing tourists to them were obscured or removed. Carl Gibson, operator of the Ruby Falls tourist attraction on Lookout Mountain, said his business is totally dependent upon outdoor advertising. Speaking for Rock City Gardens, Dick Borden said that business too is heavily dependent upon outdoor advertising along state and federal highways.*

This new fuss could not have come at a worse time. The tourism business was having a rough period in the late 1970s because of

spiraling inflation. The fuel shortage of 1979 was very nearly the last nail in the whole industry's coffin. In fact, 1979 would become known as "the year the tourists didn't come." A reporter visited Chape Chapin to find out how the crunch was affecting Rock City. Chape was brutally honest about the situation. "It can take several years to overcome a setback like this," he admitted. "Slowly and painfully, we'll do it, but I would say that two years will have gone by before most attractions are back at the levels they were at before."

Chape stated that Rock City had attracted about 100,000 fewer visitors than usual in the summer of 1979. "Basically, this summer season fell somewhere between a tragedy and a disaster. There were all sorts of warning signs, but hardly anybody was able to forecast what would eventually happen." What had happened was that vacationers, uncertain about the availability of gasoline and wary about spending too much in an age of inflation, had opted to spend the summer in their own backyards.

The 1970s were ending "not with a bang, but a whimper," as the famous poem phrased it. And as if things were not bad enough, in 1979 even Charlie the Llama, a fifteen-year resident of Rock City's deer park, died of old age in his sleep. Times were tough all over. In the past, each new decade had brought new hopes for the future, but as Chape sat in his Rock City office, staring at the nearly empty parking lot and entrance court, he was wondering whether Rock City even *had* a future.

It quite honestly looked like it might not.

Old ideas never fade away completely: this birdhouse-shaped trailer (with its "CHIRP" license plate) was the latest version of Dick Borden's rolling barn from the 1950s. *Rock City collection.*

# COME BACK TO ROCK CITY

What happens to the tourist industry when a combination of gas shortages, soaring gas prices and a widely held fear of being unable to find an open service station causes would-be tourists to simply stay at home?

That was the question the industry was facing with fear and trepidation when the 1980s arrived. The Tennessee Department of Tourist Development decided not to let the challenge find it groveling in the dirt; instead, it increased its advertising. Governor Lamar Alexander transferred $50,000 from his contingency fund to the tourism department for an "emergency" advertising campaign, assuring travelers that Tennessee had gasoline. The governor also personally encouraged Tennesseans to vacation within their home state.

Rock City may have been pushed down to the floor, bruised and battered by "da conditions dat prevailed" (as Jimmy Durante might have said), but, just as it had during the lean years of World War II, the attraction set about proving that it still had the rock-solid will to survive. To encourage conservation and safety, a new twist was added to some of the Rock City billboards along I-75, I-59, I-24 and I-72. The signs depicted Rocky the Elf driving in his car, with a slogan reminding travelers of the new fifty-five-mile-per-hour speed limit. The caption read, "Stay Alive, Go 55…And See Rock City."

Rocky had developed into an integral part of Rock City by this time. Visitors to the Gardens were now greeted at the entrance by Rocky in person, in the guise of an employee wearing an elaborate

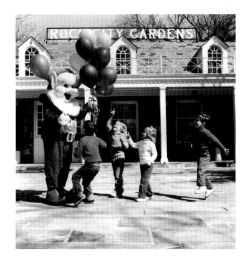

By the 1980s, a costumed Rocky was constantly present at the entrance to greet youngsters. This widely distributed publicity shot was the work of David Jenkins, who would go on to document every surviving Rock City barn in his photographs. *Rock City collection*.

costume. The costumed Rocky also went on goodwill junkets for Rock City, appearing in parades and visiting children's hospitals and tourist industry trade shows. At these functions, the colorful gnome made a greater impact than a more ordinary-looking person—such as, say, Dick Borden or Chape Chapin—might have.

Another encouraging event was the June 1980 declaration of Rock City's "birdhouse barn" on I-75 as a Whitfield County, Georgia landmark. This barn, which was actually painted to resemble a giant Rock City birdhouse, complete with artificial holes and a behemoth bird, had been created by Clark Byers's son Fred in 1968. The Whitfield County Board of Commissioners stated that the barn had "nostalgic qualities" and that many tourists had been observed stopping along I-75 to take photographs of it. In 2002, threatened with encroaching development, the barn was moved, intact, to Rock City's property at Blowing Spring, where its survival was ensured.

The summer of 1980 did little to help alleviate the previous drop in visitors to Lookout Mountain. Some racial unrest in Chattanooga's housing projects frightened many people into staying away from the whole area, and the ever-rising cost of gasoline certainly didn't do any good. The 1980 summer tourist season ended up about the same as 1979's; that is, down 20 to 40 percent from the usual totals. Rock City was not the only attraction

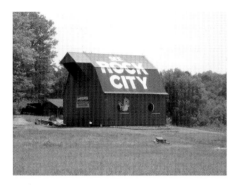

The "birdhouse barn," painted by Clark Byers's son in 1968, was declared a Historic Landmark in 1980. It was later moved from its original location along I-75 at Dalton, Georgia, to Rock City's Blowing Spring Farm property in 2002. *Author's collection.*

affected—Ruby Falls was suffering as well, while the Incline reported that it had been through one of the worst Augusts in its history.

At this time, a writer for *Atlanta* magazine, Rebecca McCarthy, dubbed Rock City "The Last of the Roadside Wonders" in an article that recounted the attraction's history with nostalgia, strangely mixed with a slight strain of sarcasm. McCarthy interviewed Chape Chapin about the changes Rock City had faced in recent years. "The person we knew as the typical tourist is all but dead," Chape said. "The market changed. People aren't as willing to experiment and take risks. So, we want to reach that person at home before he starts his trip." Then, the subject turned to Rock City's plans for survival in a new tourism world:

> *"We depend somewhat on June and September, but primarily on July and August,"* says Chapin. *"It's a distinct disadvantage doing half your business in 60 days. So we've acquired other, non-seasonal businesses to supplement this one."* A small shop in downtown Chattanooga sells computer systems and a nursery in Vero Beach, Florida, markets ornamental plants. Both have *"good potential as winter income producers,"* says Chapin, and both are doing well.
>
> It was inevitable, says one Lookout Mountain resident, that Rock City would search for new investments in distant places. There was no choice. The company had developed its 10.5-acre site as much as possible...or rather, as far as the local zoning ordinances would allow.

*Chape seemed to be resigned to this position in the community.
"Name some way you can feel, and somebody in the community
will think that way about us," he said. "Some love us. Others
would be happy if we dropped right off the mountain."*

Several locals had grown weary of the fanciful street names ("Red
Riding Hood Trail," "Cinderella Road," etc.) that Garnet and
Frieda Carter had pinned on the neighborhood. "You oughta lived
up here when it was called Fairyland, and then gone somewhere else
and let 'em know where you was from," one twenty-year resident
grumped. "It was a real problem."

During 1981, Rock City managed to move its advertising into
one area that had eluded it up to that time: churches. The Gardens
hooked up with a gospel singing group that had already been calling
themselves the Rock City Boys, and mutual promotion ensued when
the group appeared at churches of all denominations throughout the
South. They did not perform Dorothy Hedges's 1949 song about
following the yellow line, but they took with them coupons good for a
free admission to Rock City, which they passed out to the congregations.
This method of advertising was unique, to say the least.

Lookout Mountain's tourist business counted heavily on the
1982 World's Fair in Knoxville to provide some spillover crowd to
the state's other attractions. Unfortunately, the fair turned out to be
less successful than everyone had hoped, so its impact was minor
at best. However, as Rock City's fiftieth anniversary drew near,
the previous dread of the future had been modified to a cautious
optimism. Atlanta newspaper writer Howard Pousner made his
way up Lookout to see how the attraction was doing as it reached
middle age:

*Mention the possibility of change at Rock City, the tourist
attraction that turns 50 this weekend, and people look at you
like you've got rocks in your head. Sitting in a restaurant near
the entrance to the 10-acre walk-through garden, Rock City
president E.Y. "Chape" Chapin IV was so incredulous at the
suggestion of somehow altering Rock City that he almost forgot
to finish his Rock City baconburger.*

*"We haven't moved any rocks anywhere, and we don't intend to," said Chape, who was shadowed by a 20-foot-wide boulder which inexplicably had come to rest in the middle of the eatery. "There's very little that you <u>can</u> change. It took millions of years to get this way, and we can't shove it around much in the next few, and there isn't any point in trying."*

*Rock City may be an anachronism in this age of flashy amusement park rides, which seem designed only to fold, spindle, and mutilate those brave (or foolish) enough to step aboard. But there is a certain charm in the fact that it <u>is</u> dated. There's been no temptation for the owners to, say, add another state to the list you can supposedly see or turn Rock City into Six Flags Over Chattanooga, according to Chape.*

*"This is not to knock Six Flags, but they started with a swamp," the Rock City president said, digging into a stack of onion rings with an archaeologist's fervor. "Everything that is out there was created by a bulldozer or a backhoe. It's a strictly manufactured facility. Our facility is changed only to give slightly different access or perspective to essentially what has always been here, which is the rocks, the distant view, and the garden areas."*

Even so, Chape admitted that every year Rock City was receiving purchase offers from various entertainment conglomerates, and "we look at them seriously. But," he went on, "unfortunately, because of the way the place grew up, we're really going to have to have an extraordinary offer to get us to consider it."

As it turned out, Rock City would indeed ensure its future by being sold, but in a different way than the newspapers were talking about. Late in 1984, Bill Chapin, one of Chape's younger brothers, announced that he had formed a group of investors with the intention of buying Rock City. Since both Ed and Chape Chapin were, by this time, rather tired of what seemed to be a constant uphill struggle against the tide, the sale went through, and the new regime took over Rock City on January 1, 1985, with Bill Chapin as president and chief operating officer. The old 1948 corporation, Rock City Gardens, Inc., was dissolved, and its assets, including

Sequoyah Caverns, were divided among several recipients. A new corporation was formed, See Rock City Inc., and its ownership was confined to the Gardens themselves.

Rock City's new marketing/advertising director was Todd Smith, a graduate of Covenant College (which was occupying Paul Carter's old Lookout Mountain Hotel facilities). It was going to be largely his responsibility, through advertising, to boost Rock City's sagging image and take it into the future. Many facets of Rock City's advertising had been drifting aimlessly since Dick Borden's retirement in October 1982. Now, for the first time, Rock City moved heavily into TV and radio advertising, while also increasing the number of its print ads and the distribution of its brochures. Then, attention turned toward those hardy old roadside stalwarts—the billboards.

The signs still featured the traditional black backgrounds with white lettering, with the 1976 rainbow frequently included, as well. In order to give a better impression of what Rock City was all about, someone suggested that the billboards should give an impression of "clear blue skies." The decision was made to leave the billboards' design as it was, but to simply change the background color to a bright blue hue.

The Rock City sign painters, Tommy and Lynn Moses, set out on a two-year odyssey to repaint every sign. They began on the interstates and then, as time went on, gradually moved to the billboards that were

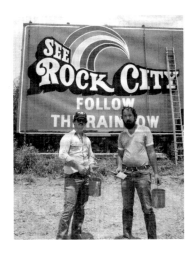

In 1985, Rock City's painters Tommy and Lynn Moses set out to replace the former black and white billboards with a new brilliant shade of blue. *Author's collection.*

still located on the older highways. During this repainting project, no alterations were made to the remaining Rock City barns, which kept their usual black rooftops with white block lettering. It was felt that, modernization aside, the barns were too much a part of Americana to be tampered with. There was also the feeling that more than one farmer might object to his barn having a loud blue roof.

The infusion of new blood must have been what the attraction needed because during the 1986 tourist season Rock City attracted 20 percent more visitors than it had during the previous season. This news even made the pages of *Time* magazine; accompanying the article was a color photo of the costumed Rocky handing out balloons at the Gardens' entrance.

One day, while a crew was taking publicity photos in the Gardens, a new idea was born. Smith recalled:

> *We were taking pictures of* [the costumed] *Rocky down by Fairyland Caverns. We didn't block off the trail or anything, we just let people go by and then we would take our pictures. And it was amazing how many people were shooting pictures of their kids with Rocky. I said to Bill, "If we added several more characters, think of how much more film we could sell!"*

(One has a mental image of that born promoter, Garnet Carter, smiling broadly from somewhere in the great beyond.)

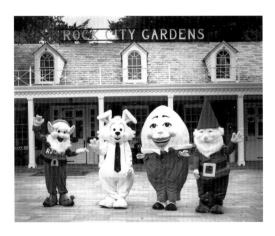

The costumed Rocky had been such a smash hit that, in the mid-1980s, other costumed characters were added to roam the property. One of Rocky's garden-variety gnome cousins can be seen at the far right. *Rock City collection.*

Some arrangements with a costume company were made, and before long the Gardens began to be inhabited by such legendary characters as the Big Bad Wolf, the White Rabbit (of *Alice in Wonderland* fame), Humpty Dumpty and other such beloved figures. In addition to all the new fairy tale characters now in place, there was someone else whom it was felt should be represented: everyone's favorite grandma, Mother Goose. Someone remembered the lady who had played Mrs. Santa Claus at Rock City the previous Christmas; she was none other than Martha Bell Miller, the very woman who had accompanied her mother and grandmother to Rock City's opening day as a young girl in 1932. In the intervening years, Ms. Miller had become a schoolteacher and then retired to open a travel agency. At the time she became Mrs. Santa Claus, she was conducting educational tours of the Lookout Mountain sites for schoolchildren.

Once Ms. Miller had put on the elaborate Mother Goose costume Rock City had designed for her, she appeared to have been born to play the role. During the peak of the tourist season, appearing as the venerable storyteller was a full-time job. In the fall and winter months, Ms. Miller was booked into elementary schools throughout the Southeast, giving entertaining and educational talks about cleanliness, good health, a positive attitude and other such worthwhile subjects. Rock City was not an overt part of these appearances, but schools that booked the Mother Goose program

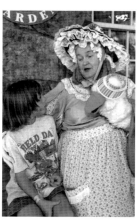

Martha Bell Miller, who as a little girl had been present on Rock City's opening day in 1932, became the attraction's official Mother Goose in 1985. She remained in the role until she retired, twenty years later. *Rock City collection*.

received coupons providing free admission to the classes that visited Rock City on a field trip.

The days were gone when a tourist attraction could just sit around year after year and wait for the visitors to come. Now, action was necessary to keep in the forefront. The Rock City publicity department was somewhat embarrassed because its press releases were still referring to Jessie Sanders's Mother Goose Village as the Gardens' "latest addition," more than twenty-five years after the Village's completion.

Some people also felt that Rock City might be shirking its civic duty by not taking steps to become "handicapped accessible," as most other businesses were. Even Bill Chapin had some concerns along these lines. After all, the Gardens' originator, Frieda Carter, had been confined to a wheelchair for a good portion of her later life, yet the wheelchair-bound citizens of the 1980s could not even enjoy the fruits of her labors. Of course, everyone realized that total access to all the parts of Rock City would always be impossible because of such natural barriers as Fat Man's Squeeze and the Needle's Eye, not to mention the narrow and frequently uneven layout of Fairyland Caverns. But the attraction did its best to oblige. A special "wheelchair trail" was devised, utilizing part of the original trail (which had been used only by employees since the late 1940s) and then swinging out to Lover's Leap and the view of seven states via Bill Chapin's private driveway.

Another problem in the new, faster-paced world seemed to be that the line of visitors waiting to enter the Gardens frequently became held up at the ticket desk by people asking questions about what they were going to see. A look at the way some other attractions had handled this yielded a common solution: Rock City needed some sort of "audio-animatronic" barker at its entrance, outside the main building, which could give a spiel that previewed the sights to be seen. Rock City's robotic greeter became Alvin the Elf, who strummed a guitar and sang country western songs between prerecorded speeches. During the peak summer season, an employee could climb into Alvin's backdrop and manipulate the elf manually, while carrying on live conversations with the tourists.

The plans for Rock City's future called for at least one new addition or improvement each year. In 1990, the addition was

One of the Rock City birdhouses was chosen as a permanent part of the Car Culture exhibit at the Henry Ford Museum in Dearborn, Michigan, in 1987. *Rock City collection.*

Cliff Terrace, a new snack shop located at Lover's Leap, where tourists could enjoy the unparalleled view while they ate. There was another view, as well, which had not previously been available. Construction of Cliff Terrace caused the removal of several trees, and the visitors now had a good look at the old Garnet Carter home (Carter Cliff), which was now, of course, occupied by Bill Chapin and his family. Up until that time, the lovely home and its landscaping had been largely hidden by the foliage.

Things went well enough that in 1990 Rock City was able to repurchase the gift shop at Point Park, which had remained under the ownership of Ed Chapin since the 1985 buyout. Jessie Sanders's realistic dioramas in the Lookout Mountain Museum were donated to Chattanooga's Regional History Museum, which it was felt could make better use of such items.

(By that time, Jessie and her husband, Michael Schmid, had moved to the Life Care Center in the Chattanooga suburb of Red Bank. Unfortunately, all efforts to determine exactly when the Rock City sculptor actually passed away have led to naught. The facility's records show no resident by either name since 1998, so apparently their exit was prior to that. At any rate, in 1998 Jessie would have been ninety-eight years old, so it is not surprising that she was no longer around by that time.)

The year 1991 saw the debut of Rock City's most ambitious radio and television advertising campaign, created by the Miller-Reid

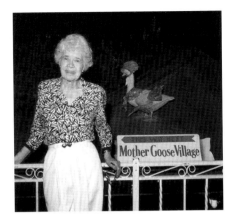

Jessie Sanders, by then ninety-one years old and a resident of the Life Care Center nursing home, paid one final visit to her beloved Fairyland Caverns and Mother Goose Village in 1991. *Rock City collection.*

agency of Chattanooga. Robert Kidder of Miller-Reid penned lyrics for a new Rock City jingle, with a tune loosely adapted from Tennessee Ernie Ford's 1951 "Rock City Boogie." The new campaign's thrust was directed toward the baby boomers who had once composed Rock City's biggest target audience. Those people now had children of their own, and Kidder's song encouraged them to relive "the good old days":

> *Come on to Chattanooga, let your kids see*
> *Rock City Gardens, "good fun like it used to be."*
> *Daddy took me down through the Fat Man's Squeeze,*
> *Bobby rode the Swing-A-Long Bridge with me,*
> *Mama saw Lover's Leap and looked at Dad,*
> *Rock City was the best time we ever had!*
> *Come back to Rock City (your kids are gonna love it),*
> *SEE ROCK CITY (on Lookout Mountain)!*
> *Rock City Gardens, "good fun like it used to be."*

The radio jingle was also used in an accompanying TV commercial that continued the same appeal to nostalgia contained in the jingle. The opening shot depicted one of the remaining "SEE SEVEN STATES" Rock City barns. Driving toward it on a stretch of two-lane highway was a family in a vintage 1950s convertible. The scene appeared to be from the hazy past until the camera zoomed

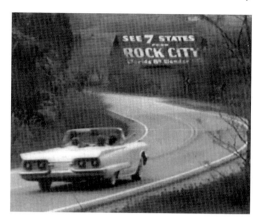

Rock City's television commercials of the early 1990s played upon the growing nostalgia for tourism history. *Author's collection.*

in on the backseat of the car to reveal a young boy operating a video camcorder. The rest of the spot followed the adventures of this obviously history-oriented family as they visited the Gardens, including an obligatory shot of a birdhouse.

Rock City's fiftieth anniversary in 1982 had been publicized somewhat, but that was nothing compared to the media blast that was planned for the sixtieth anniversary. The attraction planned to unveil not one but two new features for the 1992 tourist season. The one visitors would notice first would be a completely remodeled lobby and entrance area. The old aqua-colored plastic pool that had been the first sight in the Gardens since its installation in 1960 was scrapped; the famous water-spouting frog, which dated back to the 1930s, was carefully preserved in retirement. A new waterfall and entrance pool were built, furnished by the Tennessee Aquarium, the newest addition to Chattanooga's roster of tourist attractions. The second major addition was the Seven States Pavilion, located on the former Eagle's Nest site (which itself was the former Camera Obscura site). From this spot adjoining Lover's Leap, the flags of the seven states flew proudly.

Once past the anniversary hoopla, the improvements continued throughout the rest of the decade. We have already seen Rock City's initial attempts to install some special features for the Christmas season, but 1995 marked the debut of a completely new experience known as the "Enchanted Garden of Lights." This

The Enchanted Garden of Lights, debuting in 1995, was the culmination of more than twenty years of holiday celebrations at Rock City. Some of the original displays from the 1970s continued to be included for old times' sake, however. *Author's collection.*

was an unprecedented decorating package created by the same company previously responsible for the renowned holiday light displays at Georgia's Callaway Gardens. Even at that, some of the traditional decorations remained, such as the Nativity scene, the giant star on Lover's Leap and Santa Claus's sleigh soaring through the ultraviolet atmosphere over the castle in Mother Goose Village. Rock City's new decorations were customized to fit the existing trail and soon became a highly anticipated part of the Christmas season in the Greater Chattanooga area.

Around the same time that it was beginning to look a lot like Christmastime in the city—Rock City, that is—a photographer named David Jenkins came up with an interesting proposal. Realizing that the famed painted barn roofs were still disappearing at an alarming rate, Jenkins set out on a quest to photograph every remaining one, no matter when it was last maintained or in what sort of disrepair the structure might be. His stunning collection of images that resulted was assembled into a book titled *Rock City Barns: A Passing Era* (1996), which was largely bankrolled by the attraction and sold in bookstores and gift shops for most of the next ten years. Unlike the unpublished Garnet Carter biography of the 1970s, Jenkins's book spent little time on historical background and simply presented the barns as they appeared when Jenkins found each roadside relic.

Even though many of the barns had suffered from neglect since the double whammy of the Highway Beautification Act and

Clark Byers's accident with the electrical wires, Rock City's staff of painters continued maintaining a certain number of them for tradition's sake. When the attraction launched its new website, www.seerockcity.com, in 1997, the address was added to a few of the barn signs just as a way of bringing them into the modern-day era. The only problem was that many people felt the rickety old barns with their black-and-white signage should not be subjected to such up-to-date additions. There were enough complaints that the experiment was ended after only a few barns had received the web address. Indeed, the idea of an Internet site on a seventy-year-old barn did seem somewhat like the collision of two separate universes, so the majority of the signs were left in the original form in which Byers had created them.

Byers himself was receiving much attention in the 1990s, partly due to a series of magazine and wire service stories generated by the David Jenkins book. For a Georgia Public Television documentary in the early part of the decade, Byers had come out of retirement long enough to paint an all-new Rock City sign on a waiting barn roof, just so cameras could record the process for posterity. Byers continued to grant interviews and share his irreplaceable stories until his death on February 19, 2004, at age eighty-nine.

For years, Todd Smith and the rest of the marketing department had wanted to ditch the 1970s Rock City logo with the colorful rainbow, which by the 1990s seemed to smack of an earlier era—and not even in the nostalgic way that the barns did. (They were just thankful that the rainbow did not have a unicorn jumping over it or they would really have been mired in a bygone decade.) In 1998, the attraction enlisted the Lewis Advertising agency of Birmingham, Alabama, to come up with a new logo and ad campaign. The agency agreed that Rock City's advertising should revert to the traditional colors of black, white and red, and go back to a simpler typeface that was more reminiscent of the highway signage people remembered. Part of the new look was to replace the old painted billboards along the interstates and U.S. highways with preprinted signage that allowed actual photographs of the Gardens' sights to be presented to travelers for the first time. Soon after the new campaign was finalized, Todd Smith departed

Feeling that the 1977 rainbow logo was a relic of another era, in 1998 Rock City unveiled its new advertising campaign. It was deliberately designed to be reminiscent of the original black and white signage of the early years. *Rock City collection.*

for other careers, leaving Dick Borden's legacy of publicity first to Jim Gilliland and then to Karen Baker, both of whom carried on in the best Rock City tradition.

As the twenty-first century arrived, Rock City increased the pace of its activities outside the confines of the Gardens. In 1999, the attraction purchased the adjacent home that had formerly belonged to Garnet Carter's cousin Peyton and converted the magnificent dwelling into Grandview Lodge, which could be rented for weddings, banquets and other such events that could not have been held in the limited facilities inside the garden walls. The property below Lover's Leap at Blowing Spring, Georgia, which had been purchased in 1977, was pressed into use for seasonal events such as the Rock City Enchanted Maize. As the name suggests, this is a set of confusing paths cut into a cornfield for the entertainment and bewilderment of visitors each autumn. The Blowing Spring farm also became the locale for the Halloween season's Forest of Fear, which Bill Chapin wanted kept as far away from the actual Rock City grounds as possible to avoid frightening children. (No horror scenes or monsters were going to replace the funny and fanciful friends in Fairyland Caverns.)

For Rock City's seventy-fifth anniversary in 2007, a portion of what had formerly been Chapin's driveway was converted into Legacy Lane, a walk-through timeline of Rock City history and memorabilia. For the first time since 1937, Frieda Carter's original

In 1999,
Bill Chapin
rededicated the
former Fairyland
fire station and
its restored 1951
fire engine. *Rock
City collection.*

round entrance building was reopened to tourists, serving as a miniature museum. As for the 1937 entrance building, its function was changed when new ticket booths and turnstiles were installed in what was formerly part of the parking lot. Now the entrance court became the first sight on the tour, coming after purchasing tickets but before embarking on the Enchanted Trail.

Looking back over the events of the past seven and a half decades, perhaps no other event could have been as unforeseen as the 2007 merging of the separate marketing departments of Rock City and Ruby Falls into a single entity, R&R Marketing. After so many years of being at odds, going back to the original guide wars of the late 1930s and the battle for sign placement in the years afterward, the fact that the two Lookout Mountain tourism institutions could at last pool their marketing and advertising efforts proved that just about anyone in this tired old world can learn to get along with each other. Perhaps there is hope for the rest of us, after all.

And so, as Rock City presses onward past the three-quarters-of-a-century mark, we find the story continuing. For all the roadside advertising that made it famous, for all the newspaper and magazine articles that have described its wonders and for all the word of mouth and souvenirs that visitors to Lookout Mountain have been carting home with them all these years, there remains only one way to truly appreciate this pioneer tourist attraction. And that way, of course, is to SEE ROCK CITY.

# BIBLIOGRAPHY

## Books and Manuscripts

Capps, Anita Armstrong. *See Rock City Barns: A Tennessee Tradition.* Self-published, 1996.

Hollis, Tim. *Dixie Before Disney: 100 Years of Roadside Fun.* Jackson: University Press of Mississippi, 1999.

———. *Glass Bottom Boats and Mermaid Tails: Florida's Tourist Springs.* Mechanicsburg, PA: Stackpole Books, 2006.

———. *The Land of the Smokies: Great Mountain Memories.* Jackson: University Press of Mississippi, 2007.

Jenkins, David B. *Rock City Barns: A Passing Era.* Chattanooga, TN: Free Spirit Press, 1996.

Liebs, Chester H. *Main Street to Miracle Mile.* Boston: Little, Brown and Co., 1985.

Margolies, John. *Miniature Golf.* New York: Abbeville Press, 1987.

———. *Signs of Our Time.* New York: Abbeville Press, 1993.

Stern, Jane, and Michael Stern. *The Encyclopedia of Bad Taste.* New York: HarperCollins, 1990.

Wallis, Michael. *Route 66: The Mother Road.* New York: St. Martin's Press, 1990.

Weyman, Grant. "The Life of Garnet Carter." Unpublished manuscript in Rock City Collection, 1975.

Wilson, John. *Lookout: The Story of an Amazing Mountain.* Chattanooga, TN: John Wilson, 1977.

# BIBLIOGRAPHY

## Newspaper and Magazine Articles

*(All unidentified clippings are found in scrapbooks in Rock City's collection.)*
*Alexander City Outlook.* "Yes, Virginia." July 31, 1969.

Alligood, Leon. "Barn Paintin' Ain't What It Used To Be." *Nashville Banner*, May 19, 1992.

*Area Review.* "Rock City Enjoys a Record Year for Visitors." 1966.

Associated Press. "Balloons Supplant Barns for Slogan." June 5, 1977.

———. "Barn Advertising Fading Fast." October 11, 1983.

———. "See Rock City Ads." October 1, 1978.

Auchmutey, Jim. "See Rock City: The Story Behind the Slogan." *Atlanta Journal-Constitution*, May 10, 1992.

Beard, Marvin. "Original Tom Thumb Golf Course Quietly Passing Into Oblivion." Associated Press, July 10, 1958.

Brenner, I.C. Untitled article. *Chattanooga Times*, April 18, 1944.

Bridwell, Lowell K., and Jack Steele. "Kerr Sets Off Heated Debate." *Knoxville News-Sentinel*, June 16, 1961.

Brower, Nancy. "See Rock City: A Portion of Americana is Fading." *Asheville Times*, October 3, 1977.

Brown, Robert. "Reporter Delves Into Underground Beauties of New Mystery Cave." *Chattanooga News*, May 21, 1938.

Browne, Vivian. "Signs Confuse Driver, Tourist Alike." Unidentified newspaper clipping, n.d.

Bruce, Martha. "Rock City Land of Christmas Enchantment." *Chattanooga Times*, December 18, 1971.

Butts, Leonard. "A Sign of the Times." *Atlanta Weekly*, August 23, 1987.

Casteel, Bill. "Tourist Business Increases in Area." *Chattanooga News–Free Press*, August 18, 1968.

*Chatta-Box.* "Fairy Tales." May 3, 1928.

*Chattanooga Evening Times.* "Rock City Gardens Picketed." August 4, 1941.

*Chattanooga Free Press.* "Carter Moves to Open New Lookout Cave." May 15, 1938.

———. "Chattanooga Advertised." January 14, 1938.

———. "C of C Group Asks for Act on Guides Here." February 4, 1938.

———. "C of C Tourist Boosters Open War on Guides." January 28, 1938.

———. "Complex Local Guide Problem Reaches Chicago Newspaper." January 24, 1938.

———. "Lookout Dioramas Given Area History Museum." August 10, 1990.

153

# BIBLIOGRAPHY

————. "New Binoculars for 7 States View." June 30, 1939.

————. "Snow White in Fairyland." April 28, 1938.

————. "Tourist Guides Get Another Blow from Mistreated Indiana Man." January 26, 1938.

————. "Tourists Hit Guides Here After Meet." February 2, 1938.

*Chattanooga News.* "Atlantans to Buy Fairyland Hotel." March 3, 1931.

————. "City Guide Law is Adequate, Lambert Says." February 3, 1938.

————. "Fairyland Inn Sold for $68,000 to Atlanta Men." March 3, 1931.

————. "Guide Service Controversy is Intensified." February 2, 1938.

————. "Guides Must Get Licenses and Pay Tax." February 9, 1938.

————. "Irate Chamber Group Wars on Guide Racket." January 28, 1938.

————. "Local Attractions Will Be Advertised with 1,000 Signs." October 9, 1937.

————. "Mountain Folk Declare Open War on Guides." January 20, 1938.

————. "New Concrete Road Up Lookout Mtn. Will Be Formally Opened at Midnight." April 14, 1927.

————. "To Explore Dark Depths of 235-Foot Lookout Cave." May 20, 1938.

————. "Will Promote Incline to Get Tourists Here." October 16, 1937.

*Chattanooga News–Free Press.* "Biggest Birdhouse." November 10, 1968.

————. "Bird House in Vietnam." June 22, 1969.

————. "Chief Bill Stoner Charges Mountain Guides Hitting Hotels." January 20, 1938.

————. "C of C Parley Aimed at End of Guide War." April 1, 1941.

————. "Fairyland Must Incorporate or Lose Funds From State." February 28, 1968.

————. "FM Station to Rock City." November 23, 1967.

————. "Getting Ready for Rock City." October 28, 1954.

————. "Guides Assert No Commission Demands Made." August 4, 1940.

————. "Guides Picket Rock City, Caves." August 2, 1940.

————. "Hometown Tour." October 20, 1942.

————. "Lookout Starts Funway to Fair." June 9, 1964.

————. "Newest Book." October 27, 1960.

————. "Plans Made by Rock City." January 11, 1961.

————. "Purple Martin Tenants Get Nesting Apartments." March 14, 1969.

————. "Rock City Acquires Sequoyah Caverns." March 30, 1969.

————. "Rock City Gardens Changes Into Christmas Wonderland." November 26, 1971.

————. "Rock City Gets Injunction of Guide Pickets." August 19, 1941.

————. "Rock City Names Chapin." January 31, 1970.

————. "Rock City Observes 45th Anniversary on Lookout." May 22, 1977.

————. "Rock City Wins National Ad Award." May 1, 1962.

————. "Rock City's 21st Anniversary." May 18, 1953.

————. "Sign Removal Planned for Better View." July 20, 1971.

————. "Thrilling Mother Goose Village Latest Rock City Attraction." October 27, 1949.

————. "Tourism Heads Ask More Gas Supplies." April 13, 1980.

————. "Traffic Problem at Lookout Foot Solved by City Signs." April 27, 1961.

————. "Truce Reached in City's Long Guide Dispute." June 13, 1940.

————. "200 Foot High Observation Tower Planned at Rock City." March 22, 1946.

————. "Year of Decision Faces Lookout Mtn. Area Attractions." January 29, 1967.

*Chattanooga Times.* "Autumn Adds to Beauty of Rock City and Visitors Increasing." September 17, 1933.

————. "Billboards and the Interstate System." February 9, 1961.

————. "Borden is Named to Caverns Post." April 12, 1969.

————. "Charge of Racketeering Methods by Lookout Guides Brings Denial." January 20, 1938.

————. "C of C Committee Backs Guide Group." June 13, 1940.

————. "Coming Down." July 21, 1971.

————. "Disaster is Seen in Billboard Ban." March 2, 1961.

————. "Extortion Under Boycott Threat Charged Against Lookout Guides." January 19, 1938.

————. "Fairyland Men Plan New Club Upon Mountain." March 24, 1934.

————. "500 Hemlocks Put In Rock City Area." January 12, 1961.

————. "Foust Orders Guides to Cut Pickets to One." August 10, 1940.

————. "Guide Group Boycotts Rock City." January 22, 1938.

————. "Guide Ordinances Voted by Lookout." February 9, 1938.

————. "Guide Regulation is Chamber Plan." April 2, 1941.

————. "Guides Picketing Two Scenic Spots." August 3, 1940.

————. "Guides Renew Fight on Signs for Rock City." August 4, 1941.

————. "KOA Will Build at Valley Head." April 26, 1970.

————. "Lookout Mayor Fights Plan to Make Guides Post Bonds." February 2, 1938.

————. "Lookout Mountain Wages Beauty Battle." July 21, 1968.

————. "Mrs. Carter Wins Garden Club Prize." April 8, 1933.

————. "Picketing at Rock City Enjoined Until Hearing." September 10, 1941.

————. "Police Chief Calls Racketeering of Mountain Guides Outrageous." January 21, 1938.

# BIBLIOGRAPHY

————. "Rock City Hits the Highways." January 27, 1980.

————. "Rock City is Planning More Changes for 1968." January 28, 1968.

————. "Rock City's Fame Continues to Grow." January 27, 1965.

————. "State Promotes Billboard Curbs." December 16, 1960.

————. "Steps to be Asked to Control Guides." January 29, 1938.

————. "Steps to Fight Charges Taken by City Guides." February 1, 1938.

————. "Tourism Fights Cuts." April 13, 1980.

————. "Two Men Opposed to Billboard Ban." November 24, 1958.

————. "Visitors Welcomed to Lookout Mountain." June 15, 1927.

*Christian Recorder.* "Atop Lookout Mountain." November 16, 1944.

*Coffee Cup.* "Rock City Barns Put Out to Pasture." January 2, 1987.

Collins, J.B. "World May Read Fairy Story Written for Sick Little City Girl." *Chattanooga News–Free Press*, April 18, 1945.

*Columbus* (Georgia) *Times.* "Rock City Signs Go Dark." November 6, 1974.

Courter, Barry. "Rock City: Something to Sing About." *Chattanooga News–Free Press*, October 6, 1997.

Cox, Sylvan. "Travel in the Vacationlands of the Americas." *Miami Herald*, August 1, 1948.

Crane, Charles F. "Carters Plan Deer Park at Rock Gardens." *Chattanooga Free Press*, April 13, 1939.

CRTN News Wire. "Lover's Leap in Oils." March 22, 1971.

Dahrling, Margaret. "Rock City Improvements During 1968 Noted." *Chattanooga Times*, February 16, 1969.

Edge, Lynn. "Sign of the South." *Birmingham News*, August 27, 1995.

Fleissner, Ward. "Rock City's Charlie Llama Dies Peacefully In Sleep." *Chattanooga News–Free Press*, April 11, 1979.

Foust, Hal. "What Three Routes to South Offer Vacationeers." *Chicago Daily Tribune*, December 17, 1954.

*Gatlinburg Press.* "Rock City Gardens Named in Top Dozen Attractions." February 2, 1961.

Hamilton, Virginia van der Veer. "Before the Freeway, There Was U.S. 11." *New York Times*, November 23, 1986.

Hardin, Helen. "Tour Industry Pins Hope on Fall for Gain." *Chattanooga Times*, October 17, 1980.

Hartis, Nancy. "1979 Was Second Biggest in Tourism History Here." *Chattanooga Times*, January 20, 1980.

————. "Fall Tourist Business Follows Summer Downward." *Chattanooga Times*, September 30, 1979.

Hetzler, Sidney. "Interstate Signs Held as Factors in Tourist Drop." *Chattanooga Times*, July 30, 1967.

Higgins, Randall. "Removal of Signs Goes On." *Chattanooga Times*, October 11, 1980.

Hubbard, Russell. "Romancing the Stone." *Birmingham News*, July 26, 1998.

Hughes, John W. "Trip Made Exciting by Rock City Poker." *Calhoun* (Georgia) *Times*, July 10, 1958.

Hunter, Beecher. "She's the Mother of Mother Goose." Undated, unidentified magazine article.

*Huntsville* (Alabama) *Times*. "See Rock City Painter is Barnyard Rembrandt." July 7, 1968.

*Jasper* (Tennessee) *Journal*. "Big Birdhouse Flies the Coop." October 28, 1982.

Jenkins, David B. "See Rock City." *Country America* (September 1995).

Johnson, Julie. "Rock City's Unsung Heroes." *Chattanooga News–Free Press*, 1987.

Johnson, Steve. "Spreading Word About Rock City." Unidentified newspaper clipping, July 12, 1968.

Kemp, Kathy. "Rock City's Appeal Is Its Simple Beauty." *Kudzu Magazine*, May 29, 1992.

Kenyon, Nellie. "Carters Develop Beautiful Park in Rock City on Lookout Mtn." *Chattanooga News*, May 13, 1932.

MacRae, Ruth Faxon. "Music and Art." *Chattanooga Times*, May 8, 1932.

McCall, Pete. "Protection, Zoning Fairyland Problems." *Chattanooga News–Free Press*, February 23, 1968.

McCarthy, Rebecca R. "The Last of the Roadside Wonders." *Atlanta Magazine*, n.d.

McGaffin, William. "Heavyweight Battle: JFK vs. Billboards." *Miami Herald*, March 2, 1961.

Melton, Wightman F. "The Wonders of Lookout Mountain." *Griffin Daily News*, August 31, 1932.

*Memphis Press-Scimitar*. "Fading From Southern Scene." October 22, 1974.

Metz, George. "Rooftop Painting Has History and Tradition." *Birmingham News*, March 2, 1969.

Murphy, Reg. "Campaign to Vie With Rock City?" *Atlanta Constitution*, October 31, 1963.

Mynders, Alfred. "Next to the News." *Chattanooga Times*, October 11, 1957.

Newhouse, Eric. "See Rock City." Associated Press story, June 12, 1977.

# BIBLIOGRAPHY

Parker, Julius. "Follow Yellow Line Soon to be Saying of Past Era." *Chattanooga News–Free Press,* June 7, 1949.

Parker, Steve. "Royal Treatment Given to Couple on Dating Game Trip." *Chattanooga News–Free Press,* February 14, 1971.

Patten, Betty. "Land of Make Believe." *Chattanooga News–Free Press,* October 19, 1963.

Peck, Marion. "Scenic Views Along Highway Being Blocked." *Chattanooga Sunday Times,* January 29, 1961.

Pennekamp, John. "Georgia Wants You to Know Lookout Mtn. is There." *Miami Herald,* June 11, 1949.

Pennington, Charles. "Edward Young Chapin III." Undated, unidentified newspaper clipping.

Pousner, Howard. "A Bit of Americana Rolls Past the 50-Year Mark." Unidentified newspaper clipping, May 15, 1982.

Prather, James D. "Cave Like Dream in Fairyland." *Chattanooga Free Press,* May 21, 1938.

———. "New Lookout Cave Project Planned by Chattanoogans." *Chattanooga Free Press,* May 16, 1938.

Prins, Carol. "It's Not Just a Job, It's an Adventure." *Chattanooga News–Free Press,* January 18, 1987.

Rickard, Maureen. "Touring Billboard Alley." *Knoxville News,* June 14, 1961.

Robison, Wynola. "Survey Finds Interstate Not Hurting Route 41." *Chattanooga Times,* April 11, 1962.

Sams, Marilyn. "Balloon Provides Visible Lift for Chattanooga's Rock City." Unidentified newspaper clipping, n.d.

Schneider, Fred C., Jr. "Do Fleas Force Visitors to Flee Our Fair City?" *Chattanooga News,* January 28, 1938.

Segura, Chris. "Rock Attraction has Variety of Displays." *Chattanooga News–Free Press,* October 12, 1970.

Steele, Jack. "Senate Nears Showdown on Billboards." *Knoxville News,* June 14, 1961.

*St. Petersburg Times.* "Rock City's Rollin' Barn." January 30, 1955.

Tasker, Fred. "Barn Roofs Were Never Full of Hot Air, At Least." Unidentified newspaper clipping, July 16, 1970.

*Tennessee Visitors Guide.* "World's Biggest Birdhouse Promotes Rock City." July 1968.

Terral, Rufus. "Lover's Leap on Lookout Mountain." *Chattanooga Sunday Times,* September 22, 1935.

*Time.* "Tom Thumb from Tennessee." July 14, 1930

Travis, Fred. "Outdoor Sign Act to be Enforced." *Chattanooga Times*, October 17, 1965.

———. "State Studies Question of Trimming Around Signs." *Chattanooga Times*, October 1977.

Unger, Henry F. "Storybook Gardens." *Buick Magazine* (June 1947).

Unidentified newspaper clipping. "All Mother Goose Village Cottages in Fairyland Occupied for Summer." July 13, 1930.

———. "Attorney Says Officers Held Guide Pickets." August 17, 1941.

———. "Barn Declared Landmark." N.d.

———. "End of Rock City Barn Signs to be Marked by Art Contest." N.d.

———. "Fairyland Is Everything Its Name Implies." N.d.

———. "Fairyland Opened to General Public." N.d.

———. "Fairyland Opens New Attractions." N.d.

———. "Fairyland Projects Nearing Completion." N.d.

———. "Fairyland Seeks Vote in Incorporation Move." January 1968.

———. "Fairyland to Grow on Top of Lookout." N.d.

———. "Fairyland's First Day Sales Over $300,000." N.d.

———. "Great Stone Slips to Hide Civil War Military Cache." March 17, 1939.

———. "Guides Defend Mountain Sign." July 7, 1949.

———. "Highway Takes Old Pike Route in Last Survey." August 14, 1930.

———. "Local Guides Exonerated by C of C Group." May 27, 1941.

———. "Lookout Guides Give City Black Eye With Tourists." N.d.

———. "Lookout Mountain Park." February 3, 1925.

———. "Mighty Ad From Tiny Golf." N.d.

———. "Name This Cable Bridge in Rock City and Get $1." May 6, 1932.

———. "New Entrance to Rock City Erected." May 1, 1937.

———. "Pennsylvanian Pays $200,000 for Baby Golf." July 16, 1930.

———. "Riches or Relics?" March 16, 1939.

———. "Rock City Beautified by Fairyland Company." February 17, 1932.

———. "Rock City Inspires New Poetic Efforts." September 1974.

———. "Rock City View Tourists Don't Get." September 8, 1940.

———. "Rock City's Entire Lobby Wall To Be of Glass." January 7, 1960.

———. "Signs on Rock City Extend 800 Miles." April 19, 1947.

———. "Stretch of New Lookout Mountain Road." April 17, 1927.

———. "*Time* Magazine Tourism Story Cites 20% Gain at Rock City." May 1986.

United Press International. "Rock City's Familiar Signs Atop Barns to Disappear." September 11, 1974.

# BIBLIOGRAPHY

————. "Show Me the Way to Old Rock City." October 6, 1974.

*Walker County* (Georgia) *Messenger*. "Rock City Boys Getting Boost." May 27, 1981.

Wilcox, Pat. "Controls: Travel Industry Hits Billboard Plan." *Chattanooga Times*, February 21, 1981.

Williams, Michelle. "Rock City Barns Almost Extinct." Associated Press, 1992.

Wilson, John. "Rock City Buys Woods in Valley." *Chattanooga News–Free Press*, August 9, 1977.

## Personal Interviews and Correspondence, 1991-92

Karen Baker, Dick Borden, Clark Byers, Bill Chapin, Ed Chapin, Peg Lamb, Martha Bell Miller, Catherine Myers, Jessie Sanders Schmid and Todd Smith.

## Other Sources

Brochures, postcards, photographs, souvenirs, press releases and newsletters produced by Rock City Gardens between 1932 and 2008.